Diego Velázquez

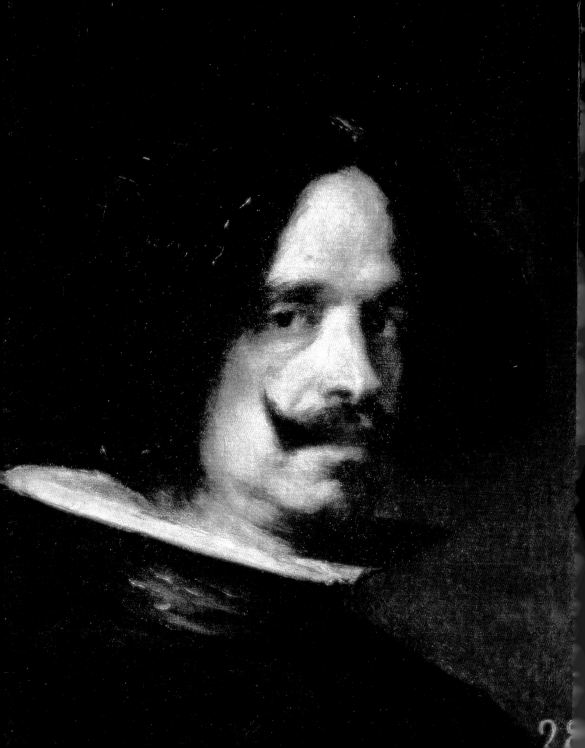

Dieter Beaujean

Diego Velázquez

Life and Work

KÖNEMANN

Youth
page 6

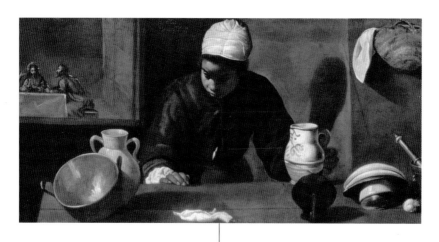

1599		1610	
	1630		1635

Italy and Spain
page 38

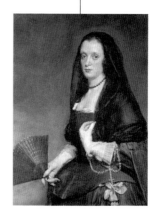

Art and Politics
page 52

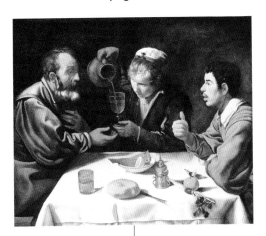

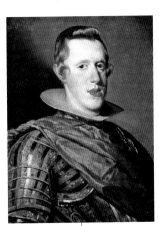

1620

1625

1650

1660

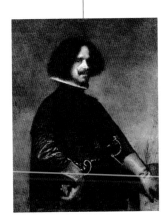

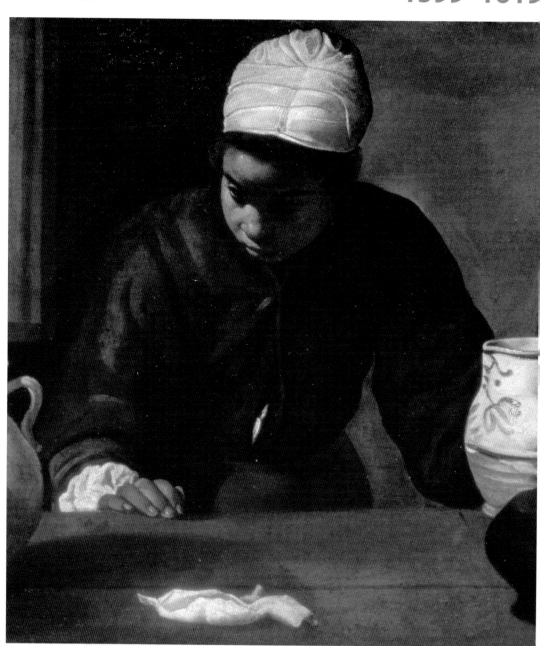

Diego Velázquez was one of the greatest European painters of the 17th century, a period dominated by the Baroque. Born in 1599, he was the eldest of seven children from a noble Seville family. His upbringing instilled in him the values and beliefs of his parents. The young Diego was an eager pupil whose artistic talents were recognized and encouraged early in his life. At the age of 10 he was apprenticed to the painter Francisco de Herrera the Elder but changed teachers soon after to enter the workshop of Francisco Pacheco, who taught him the techniques of painting as well as the basics of anatomy, perspective, geometry and architecture. Pacheco introduced him to literature and people who were to influence his further development. In 1617 Velázquez completed his apprenticeship as a master craftsman and the following year he married Juana Pacheco, his teacher's daughter. He embraced all the major contemporary innovations in European art with enthusiasm, incorporating them into his early pictures with great self-assurance.

William Shakespeare, portrait c. 1640

The Cathedral of Santa Maria at Seville, begun 1506

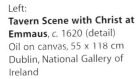

Left:
Tavern Scene with Christ at Emmaus, *c.* 1620 (detail)
Oil on canvas, 55 x 118 cm
Dublin, National Gallery of Ireland

Right:
Head of a Girl, *c.* 1618
Drawing, 20 x 13.3 cm
Madrid, Biblioteca Nacional

1599 Anthony van Dyck, the Flemish Baroque painter, is born. William Shakespeare writes the dramas *As You Like It* and *Much Ado About Nothing*.

1600 Henry IV of France marries Maria de'Medici. Peter Paul Rubens travels to Italy where he remains until 1608.

1601 Michelangelo completes *The Crucifixion of St Peter* and *The Conversion of St Paul*.

1603 Death of Queen Elizabeth I of England.

1606 Rembrandt Harmensz van Rijn is born.

1609 The last Moors are expelled from Spain. Ceasefire agreed between the Netherlands and Spain until 1621.

1618 Beginning of the Thirty Years' War.

1599 Velázquez born in Seville, the first of seven children. He is baptized on 6 June in the parish church of San Pedro.

1610 Begins his apprenticeship as a painter with Francisco de Herrera in Seville but after a few months changes workshops to continue his studies with Francisco Pacheco.

1611 Velázquez's father and Pacheco sign a contract for a six-year apprenticeship.

1617 The artist qualifies as a master craftsman on 14 May.

1618 Marries Juana Pacheco, his teacher's daughter.

1619 Birth of their first daughter, Francisca, who is baptized on 18 March. Velázquez paints the *Adoration of the Magi*.

Apprenticeship in Seville

Francisco Pacheco
Portrait of Francisco Gomez de Quevedo y Villegas, 1599
Print
Madrid, Biblioteca Museo Galdiano

Velázquez's teacher made this engraving to illustrate a book on the lives of famous people.

Diego Rodríguez de Silva y Velázquez was born to Don Juan Rodríguez, the descendant of an ancient Portuguese noble family, and Doña Gerónima Velázquez, a member of the Seville aristocracy. He was baptized on 6 June 1599 and named Velázquez after his mother in accordance with Andalucian tradition.

Strategically situated on the banks of the Guadalquivir river, Seville was one of the most prosperous trading cities in Europe, its status greatly enhanced since the European discovery of the Americas in 1492. The young Diego grew up surrounded by wealth, power and art, and his education was both thorough and comprehensive.

A. A. Palomino, an artists' biographer working in the early 18th century, wrote that in 1609 Velázquez had already spent several months as an apprentice in the studio of the painter Francisco de Herrera the Elder. Herrera was said to have counterfeited coins, and only managed to escape punishment by entering a Jesuit monastery. The Spanish king visited the monastery in 1624 and was so impressed by Herrera's *Apotheosis of St Hermen-gild* that he pardoned the painter, later taking him into royal service in Madrid. Herrera's coloration, which tended to the dark or brownish end of the

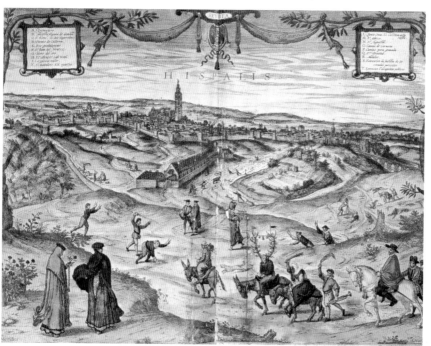

German copperplate engraving
View of Seville, 1593

The seat of an archbishopric and capital of the Andalucian province of Seville in the south of Spain, the city had a Moorish alcazar, a Gothic cathedral and its own harbor on the river Guadalquivir. In its heyday Seville, together with Cádiz, had sole trading rights with the newly discovered American continent. In the 17th century Seville was an internationally renowned trading town, cultural center, and held great political power.

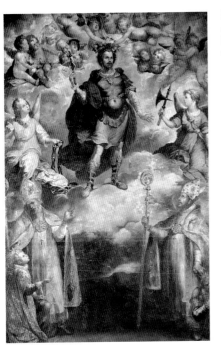

Francisco de Herrera
Apotheosis of Saint Hermengild, 1624
Oil on canvas
100 x 88 cm
Seville, Museo de Bellas Artes

St Hermengild was persuaded by his wife to convert to Catholicism in 1585. According to the Church he was later executed for his faith and soon came to be venerated as a martyr. In 1586 he was canonized in Spain, a measure which was later extended to the entire Catholic Church. Herrera's picture shows the saint's apotheosis.

the young artist became familiar with a range of contemporary scholarly issues as well as the fundamentals of literature. It was during this time that he got to know the great Spanish artist Francisco de Zurbarán.

On 14 May 1617 Velázquez successfully completed his apprenticeship by passing the master craftsman's examination in the presence of Pacheco, his teacher, and two representatives of the Guild of St Luke. Accepted into the Painters' Guild of Seville, Velázquez was now able to set up an independent studio, sign and sell his own works, and teach.

In the following year Velázquez married Pacheco's daughter Juana, and in 1619 the first of their two daughters, Francisca, was born.

palette, is also characteristic of Velázquez's early pictures.

In December 1610 the young Velázquez entered the studio of Francisco Pacheco, with whom his father signed a six-year apprenticeship contract on 17 September 1611. As was customary, the young apprentice moved in with his teacher's family, and soon developed a close relationship with them. Pacheco instructed Velázquez in the basic techniques of painting and introduced him to the themes from which an artist was expected to draw his material. Pacheco's house was a meeting place for Seville's intellectual elite and this stimulating atmosphere proved valuable for Velázquez later in life; from the individuals who met there,

View of the Alcázares Reales in Seville, photo

The palace buildings in Seville were constructed over centuries. Their origins can be traced back to 11th century Arab rule. Today the core of the palace is formed by sections built under Pedro the Cruel (1350–1369). The Catholic monarchs, Isabella and Ferdinand V, later redesigned the palace according to their respective needs. In the 19th century the palace was comprehensively renovated.

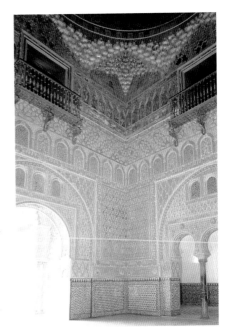

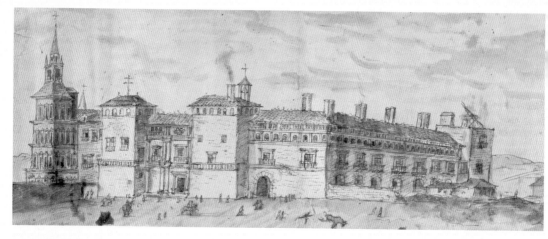

17th-century Spain

The 17th century – the age in which Velázquez created some of the most profound work in the history of art – was a time of political, economic and social decline for Spain. At the beginning of the 14th century Spain was a minor country on the periphery of Europe, but within 200 years it had developed into the continent's greatest power, establishing a colonial empire along the way. Under Philip II (1580–1598), Crown policies were initially liberal, and in the second half of the 16th century the country experienced a cultural flowering, due to influences from Italy and the Netherlands. The vast royal residence of El Escorial, 50 km (30 miles) west of Madrid, is a reminder of this age; Velázquez's first teacher, Herrera, worked here as an architect. El Escorial, which Philip II intended as an architectural manifestation of his power, encompassed palace, monastery, church, university and royal crypt. By the end of the century, however, this attempt to concentrate power, as well as the State's growing political intolerance, gave rise to opposition on both the domestic and international fronts. In 1598 the 20-year-old Philip III (1598–1621) ascended to the throne, and with him began Spain's gradual decline. The Empire's

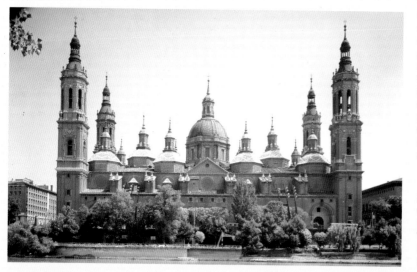

Zaragoza, Nuestra Señora de Pilar, Francisco de Herrera the Younger and Ventura Rodríguez
Photo of the church built between 1677 and 1753

Opposite:
Anton de Wingaerde
The Alcázares of Madrid,
1569
Drawing
265 x 425 cm
Vienna, Austrian National
Library

deteriorating political and economic position forced the Crown into a defensive foreign policy. Philip IV (1621–1665) later tried to restore Spain's international prestige by embarking on a series of unsuccessful military campaigns against both France and the Netherlands. From 1665 to 1700 the throne was occupied by Charles II, Spain's last Habsburg ruler. Charles was, however, no longer able to maintain the integrity of the state by relying on his own resources. The decline of Spanish rule from the mid-17th century eventually started to have a negative effect on the country's cultural production. In contrast to the early 17th century, when many palaces, churches and monasteries had been built, few state buildings were constructed during the reign of Philip IV and his successors. During this

period, building work was mainly limited to Baroque style renovations. Only those artists prepared to glorify the Crown and the Church received patronage. The generally poor state of the country meant that no first-rate international artists – which usually meant Italian ones – could be induced to work at the court, which then tended to resort to less gifted local artists. This lack of international competition was probably a key reason why Velázquez's early career was so meteoric. In spite of

this head start, however, the young Seville artist would quickly prove himself to be among the greatest in his profession. Velázquez had soon realized that his dream career was only possible at court, and he put all his energy into attaining this goal. His ambition and his ability were to make him one of the greatest painters of the 17th century.

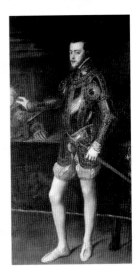

Titian
Phillip II, 1551
Oil on canvas
193 x 111 cm
Madrid, Museo del Prado

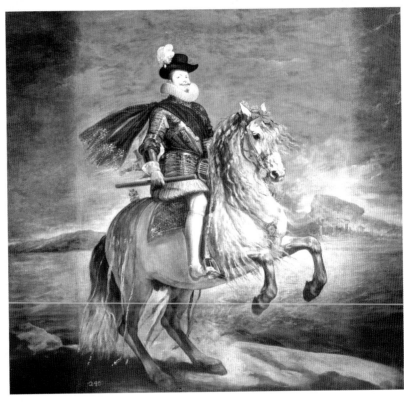

Bartolome Gonzalez
Equestrian portrait of Philip III of Spain, partly painted over and added to by Diego Velázquez in 1635
Oil on canvas
300 x 314 cm
Madrid, Museo del Prado

The Influence of Caravaggio

At the end of the 16th century the art world witnessed the short but brilliant career of a young man whose work would have a major influence on European painting in the following century: Michelangelo Merisi da Caravaggio (1571–1610). A native of Milan, Caravaggio was supported by influential patrons in Rome, where he settled after completing his apprenticeship, and where he received several prestigious official commissions. The contradictions within his personality – he was a turbulent character involved in countless brawls as well as a sensitive painter of the human condition – seems to have been crucial in forming his epoch-making style. Caravaggio's breathtaking compositions pushed the figures hard up into the foreground, rendering them as half-length figures.

Top:
Michelangelo Merisi da Caravaggio
The Fortune Teller, 1594–1595 (detail)
Oil on canvas
99 x 131 cm
Paris, Musée du Louvre

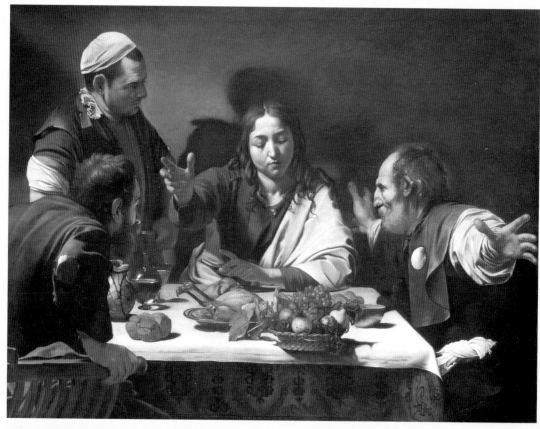

Merisi (Caravaggio) thinks that there is nothing better than following the example of Nature and before every brushstroke he closely examines the life of what he is painting.

Carel van Mander (17th century Dutch writer on art)

He also transferred elements of genre painting to history painting, an example of which can be seen in his portrayal of simply clad figures with dirty feet kneeling before the Madonna del Rosario. In this work Caravaggio relaxed the normally strict hierarchical order of Madonna and Child, Dominican monks and donor by allowing the humble recipients of the garland to displace the wealthy figures to one side. Caravaggio's paintings were considered revolutionary by his contemporaries and his work had a profound impact on other artists, including those outside his native Italy. His art often encountered vehement opposition from his clients, however, and it was not unusual for completed pictures to be rejected. Velázquez probably came into contact with Caravaggio's paintings through the Prior Camillo Contreras, who returned to his hometown of Seville with several examples of

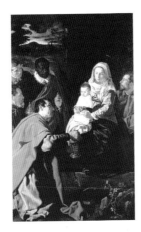

Adoration of the Magi, 1619
Oil on canvas
204 x 126.5 cm
Madrid, Museo del Prado

the Italian's work, though the Spanish artist was also able to make use of various engraved reproductions. Velázquez was to remain influenced and inspired by Caravaggio's work, adopting several of his compositional elements, such as the depiction of Biblical and mythological figures as individuals drawn from daily life, as well as the marked chiaroscuro contrasts.

The division of color in Caravaggio's *Madonna del Rosario* into three horizontal zones was the basis for Velázquez's tripartite chiaroscuro

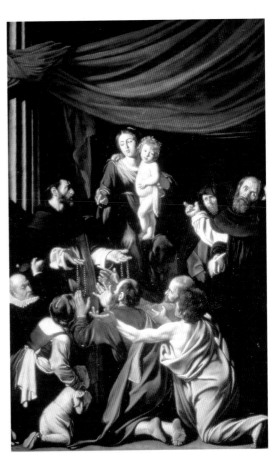

scheme for the coloration in his own work on the same subject. In his own *Adoration of the Magi*, Velázquez shaped Caravaggio's intensely naturalistic characters into a scene of worship that also featured remarkably lifelike individuals.

Michelangelo Merisi da Caravaggio
Madonna del Rosario, before 1607
Oil on canvas
364 x 249 cm
Vienna, Kunsthistorisches Museum

Facing page:
Michelangelo Merisi da Caravaggio
The Supper at Emmaus, 1601 (detail)
Oil on canvas
London, National Gallery

Early Works

Diego Velázquez's qualification as a master craftsman in 1617 gave him the right to set up his own studio and sign and sell his own pictures. Unfortunately the artist's works are not as thoroughly documented as his biography, especially as he seldom signed or dated his pictures. Indeed, the earliest known dated work by Velázquez is from 1618.

Pacheco's treatise on painting, in which he gave a prominent place to the achievements of his son-in-law, refers to Velázquez's early works as drawings and *bodegones*, which is a Spanish type of genre painting (pp. 18–19).

Like most painters in 17th century Seville, the young Velázquez dealt mainly with religious themes.

Three Men at Table, ca. 1618
Oil on canvas
108.5 x 102 cm
Saint Petersburg, Hermitage

Velázquez's composition – with the two younger men staring out at the viewer, the raised carafe of wine and the table positioned in the immediate foreground – seems to invite the viewer to take part in the meal. The scene is strongly reminiscent of work by the Italian painter Caravaggio (pp. 12/13), whose naturalistic paintings had a great influence on Velázquez. This scene rooted in daily life is almost certainly derived from Velázquez's study of the Italian artist, as are the realistically depicted figures and the still-life arrangement of the objects on the table. The evocative handling of light and color emphasizes the visual nature of the experience. Paintings of this type can be found only in Velázquez's youthful period; later he turned to other themes.

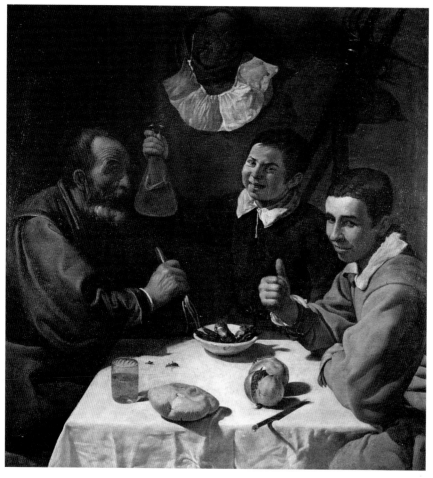

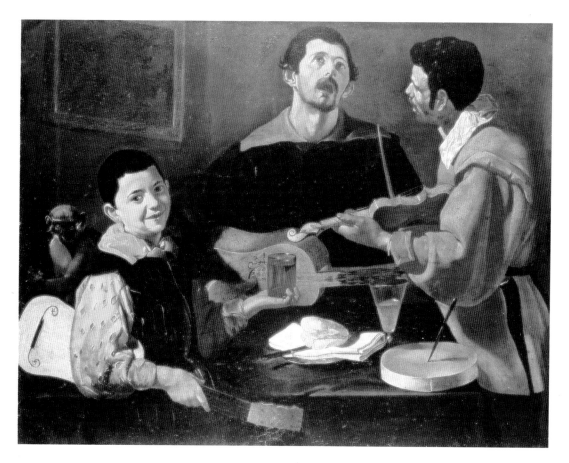

Three Musicians,
1616–1620
Oil on canvas
87 x 110 cm
Berlin, Staatliche
Museen zu Berlin,
Preußischer
Kulturbesitz,
Gemäldegalerie

The uniqueness of
this work lies in its
realistic depiction of
an everyday 16th-
century scene
combined with clear
elements.

Velázquez's teacher, Pacheco, had published a treatise on the various themes in painting, with which his pupil was also familiar. This treatise contained suggestions for the compositions of a range of artistic subjects, as well as providing practical information on how to realize them. Velázquez did not always follow his teacher's guidelines, however; early in his career he began to develop his own approach, often drawing on the example of Caravaggio (pp. 12–13) to influence his style.

Velázquez first became known for his genre pictures, although religious themes sometimes still resonated in these works, as in the two paintings *Three Men at Table* and *Three Musicians*. The most salient feature of paintings such as these was always that the objects and figures they depicted were drawn from everyday life.

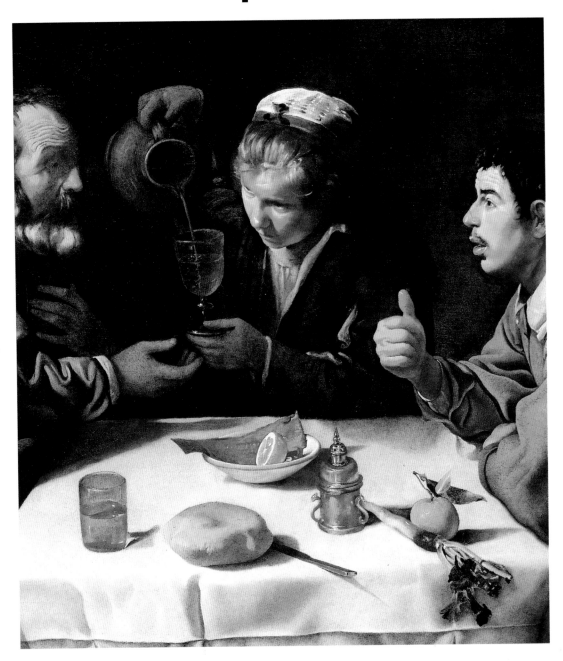

All great artists want to measure their talents against the very best of their time, to develop their own unique style by engaging directly with the most successful and progressive work in their field. Velázquez's search for his own form of expression by no means came to an end when he completed his formal apprenticeship. As a young, independent master painter, he sought artistic reference points which he might use as a model for his work, even though the only artist of repute in the city was his former teacher, Pacheco. Velázquez searched beyond the art of his native town; absorbing the influences of Flemish and Italian colleagues such as Rubens and Caravaggio. These artists played a critical role in his development, their influence clearly visible in his early scenes from everyday life, and in his portraits and religious images.

General Albrecht Wallenstein, ca. 1620

Portrait of a Man (self-portrait), ca. 1622

1620 Jan Tserclaes von Tilly, general in the Catholic League in the Thirty Years' War, defeats the Protestant Union under King Frederick V of Bohemia. In 1630 he succeeds Albrecht Wallenstein as commander-in-chief.

1621 The Flemish Baroque painter Anthony van Dyck travels to Italy, where he remains until 1627. General Tilly occupies the Palatinate in Germany and its capital, Heidelberg. Philip IV becomes king of Spain, reigning until 1665. End of the 12-year armistice with the Netherlands. War with Spain leads to the division of the country.

1619 Velázquez paints the *Virgin of the Immaculate Conception* and his first portraits.

1620 Paints his first masterpiece *The Water Seller*.

1621 His second child, Ignacia, is baptized on 1 January; she dies while still in infancy.

Opposite:
Peasants at Table,
1618–1619 (detail)
Oil on canvas, 96 x 112 cm
Budapest, Szépmuvészeti Múzeum

Right:
Saint Paul, ca. 1619
Oil on canvas, 99 x 78 cm
Madrid, Museo del Prado

The Painter of Bodegones

Velázquez initially worked as a painter of *bodegones* – a new and peculiarly Spanish art form within genre painting. "Bodegón" is Spanish for tavern, and the subject matter of this type of painting consisted of everyday scenes from inns or kitchens with their arrangements of food, drink and kitchen utensils. Velázquez, one of the first proponents of this genre, which he had already begun to favor during his apprenticeship, went on to become one of its most famous practitioners. From an early age the artist was fortunate enough to be able to devote

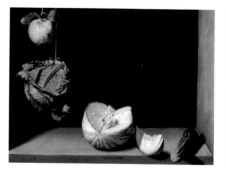

Juan Sánchez Cotán
Still-life, 1600
Oil on canvas
66 x 82.8 cm
San Diego, Museum of Art

An example of a *bodegón* by the painter Cotán who, like Velázquez, devoted himself to this Spanish genre.

Kitchen Scene with Christ in the House of Martha and Mary, 1618
Oil on canvas
60 x 103.5 cm
London, National Gallery

A *bodegón*, combining religion and daily life.

himself to the art of his choice as his wife, Juana Pacheco, had received "several houses" in her dowry. This enabled the young artist to work solely on his *bodegones*, then considered an inferior type of art and therefore not greatly in demand. For this reason Velázquez's teacher Pacheco (who later painted many *bodegones*

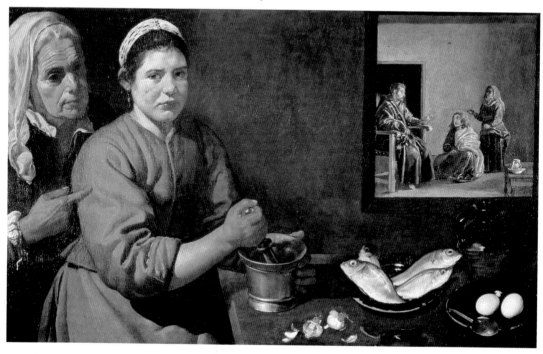

himself), and his biographer Palomino, sought, in their writings, to praise the young man's unique achievements in this genre.

Palomino, for example, wrote that several people had suggested to Velázquez that he would be better off studying more serious subjects, and that he could learn much from the delicacy and beauty of a painter like Raphael. The young artist is said to have replied that "he preferred to be first in that kind of crudeness than second in delicacy." Of the approximately 20 pictures Velázquez painted in Seville between 1617 and 1622, eight can be considered *bodegones* including – and in spite of its ostensibly Biblical subject matter – *Kitchen Scene with Christ in the House of Martha and Mary*. The primary intention of the artist was to recreate, in as realistic a manner as possible, a scene featuring simple folk and faithfully rendered kitchen utensils, while the scene of Christ being given food and drink is cleverly staged as a narrative pretext.

The combination of a kitchen scene in the foreground with the Biblical event occurring on a smaller scale in the background – glimpsed here through an opening in the wall which gives on to an adjacent room – was a popular technique in Dutch painting of the late 16th and early 17th centuries. Pieter Aertsen (1503–1575) and his nephew Joachim Beukelaer (1533–1573) were the most adept painters of such motifs, mainly through the distribution of high-quality reproduction engravings. The

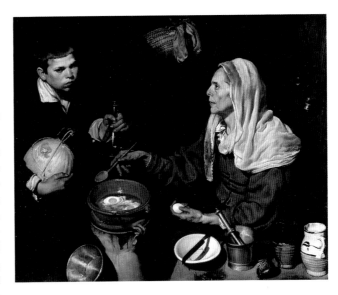

composition of early works by Velázquez cannot match those of his Dutch predecessors for harmony, and the objects in his paintings are often more skillfully reproduced than the figures. In *Old Woman Cooking Eggs* from 1618, however, the painter was already displaying a sure feel for pictorial structure; the figures are no longer merely discrete forms but fully integrated into the composition. Here, it is the precise depiction of different types of materials that has priority while the everyday scene of food preparation is of only secondary importance.

Velázquez enjoyed an enormous success with his *bodegones* in Spain. A number of his colleagues attempted to imitate his unique touch – not least of them was Pacheco – without ever approaching the expressiveness and immediacy of their forerunner.

Old Woman Cooking Eggs, 1618
Oil on canvas
100.5 x 119.5 cm
Edinburgh, National Gallery of Scotland

This painting is an excellent example of a Velázquez *bodegon*. It was greatly admired by his biographer Palomino. The pictorial components, coloration and treatment of light are employed in such a way that the gaze of the viewer is directed towards the real theme of the painting – the still-life objects in the foreground around which the cook and her assistant are merely grouped as a narrative frame.

Genre Painting in the Netherlands

The concept of genre painting derives from the late 18th century. Previously in the Netherlands specific descriptive terms for various motifs had been used, such as "Conversation in Merry Company." Netherlandish genre painting had its roots in the background scenes of late-medieval religious panel paintings, the depictions of professional bodies and the cycles of the seasons, as well as in certain religious subjects that had a genre-like character.

Genre painting is a branch of visual art dedicated to daily life and in Holland – as the Republic of the United Provinces of the Netherlands was known for short – it was brought to a peak of perfection.

In sociological terms, genre painting had its roots in the new social order of Holland: the citizens of this young and prosperous republic wanted to see their wealth displayed and their own world idealized in paint. Genre painters were best suited to fulfill this requirement because of their special skills in depicting scenes from the everyday life of the common people.

Spanish painters of the 17th century increasingly began to turn their attention to new artistic developments both at home and abroad; painters such as Pieter Aertsen (1503–1575) and Joachim Beukelaer (1533–1573) can be cited as specific examples of foreigners who influenced the Spanish genre of the *bodegon*. Dutch art also left its mark on Velázquez's *bodegones* in that he too adopted the practice of placing people from humble stations in life at the center of what are highly sophisticated paintings.

Jan Vermeer, called Vermeer van Delft
The Letter, 1667
(Detail)
Oil on canvas
44 x 39 cm
Amsterdam, Rijksmuseum

Quentin Massys
The Moneylender and His Wife, 1514
Wood
71 x 68 cm
Paris, Musée du Louvre

Quentin Massys painted a subtle satire in *The Money-lender and his Wife*, a work that calls to mind the Biblical parable of the rich man (Luke 12: 16–21). The painting mocks "lip-service Christians", note the figure of the woman who looks greedily at the money while flicking mechanically through her prayer book. At the same time it is a detailed depiction of a money-changer at work featuring all the tools of the profession as they were used at the time in Europe's major trading centers (in this case, Antwerp). Pieter de Hooch (1628–1684) and Jan Vermeer (1632–1675)

are among the best-known practitioners of genre painting in the 17th century, the Golden Age of Dutch painting. De Hooch began as a painter of soldiers but later changed to depictions of lavish interiors animated by occasional figures seen performing often trivial tasks. Jan Vermeer was a master of light, technique, pictorial structure and scenes of contemplation. His aristocratic figures were shown in immaculate domestic settings, dressed expensively and engaging in cultural activities such as playing music, singing or reading letters. At first glance Vermeer's pictures often appear puzzling: his protagonists are bound up in their own inner world and seem to be beyond the reach of the viewer. Genre painters preferred and took pleasure in a sophisticated

treatment of light and color that made the most valuable materials and textiles appear "tangible." Items from everyday life, as well as treasured possessions, were arranged as a still-life, whose ostentatious display was designed to capture the attention of a viewer conceived of as a casual passerby. Ultimately, viewers were supposed to see themselves and their world reflected in these pictures. Some art historians see hidden layers of meaning in the details of genre painting, which the educated viewer would have known how to decode. A common feature of all these painters was their choice of subject matter taken from private moments in the lives of

normal people, or from the domestic routines of wealthy women and their immediate surroundings. Velázquez's genre painting shows clear parallels to Dutch painting in its treatment of materials, composition, light and color. The viewer, however, searches in vain for hidden meanings in his work, which depicts a remarkable array of diverse materials.

Pieter de Hooch
Learning to Walk, ca. 1660
Oil on canvas
67.5 x 59 cm
Leipzig, Museum der Bildenden Künste

The First Masterpiece – the Water Seller

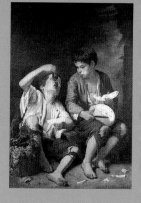

Velázquez's best picture, from the period before his move to Madrid in 1623, is *The Water Seller*, long known under the title *The Corsican of Seville*. Velázquez's painting depicts the imposing figure of a water seller – a familiar sight on the streets of Seville, as in many other southern cities. The old man's left hand rests on a clay jug from which he has apparently just filled the goblet that he now offers to the boy. The young boy stands in the background holding a water glass in both hands. The harsh light, entering the frame from the upper left, dramatically brings out the two figures in the foreground, and makes the still-life of table, jugs and glass stand out from the rest of the composition. In contrast to the French artist Georges de La Tour (1593–1652), who was a master of evocative nocturnal settings created by painting daily scenes illuminated by candlelight, Velázquez chose to use daylight. The intensity of both light and color recedes towards the background of the painting, a technique Velázquez used to convey the illusion of depth. The lines on the suntanned skin of the water seller and on the surface of the large jug, as well as the smooth, slightly chubby face of the boy and the finely grooved surface of the smaller jug, show a talent for naturalistic depiction that is just as sensitive to objects as it is to human figures. The painter's interest in the characteristics of objects is shown in his differentiated rendering of various textiles and in the impressive naturalism of his materials, be they three drops of water on a jug or

Bartolomé Estéban Murillo
Boys Eating Fruit,
ca. 1645/46
Oil on canvas
146 x 104 cm
Munich, Alte Pinakothek

a fig in a water glass. Compared with the obvious delights of the picture's surface, the expressive and gestural language of Velázquez's figures is more muted and possesses a dignified tranquility. The painting shows a world where the simple act of passing on a glass of water becomes a complex rite filled with great reverence. The work of Bartolomé Estéban Murillo (1618–1682) was marked by a profound piety and, like Velázquez, he drew inspiration from the daily scenes he observed among the people who crowded Seville's streets. Almost 20 years younger than Velázquez, Murillo became famous with works such as *Boys Eating Fruit*. The closeness of his subject matter to Velázquez's *Water Seller* is further proof that

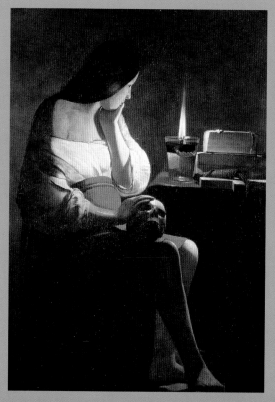

Georges de La Tour
Mary Magdalene Meditating with a Skull,
ca. 1620
Oil on canvas
128 x 94 cm
Paris, Musée du Louvre

He rose in his field so as to yield to no one, thus winning great fame and well-deserved esteem by his works. Of these we should not pass over in silence the painting known as the Water Seller ...

From Palomino's biography on Velázquez, 1724

scenes of everyday life were popular in 17th century Spanish painting. Velázquez painted his *Water Seller* in 1619/20. He took the painting with him to Madrid in 1623 as evidence of his art, and probably gave it to his first patron Don Juan Fonseca, chaplain to Philip IV. The painting is Velázquez's only known work to have been recorded during his lifetime: it was entered in the inventory of Fonseca's estate. The artist himself was entrusted with inspecting the paintings of his former patron's estate and estimated his *Water Seller* to be worth 400 reales – more than any other painting in the collection. The success achieved by this painting is also proved by the numerous copies, which the painter himself made of the picture at the request of potential clients. This is why there are several "originals" of *The Water Seller* that exist today.

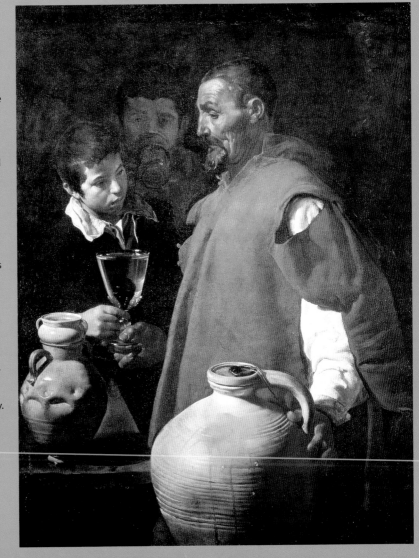

The Water Seller, ca. 1620
Oil on canvas
106.7 x 81 cm
London, Wellington
Museum, Apsley House

Early Portraits

The pictures Velázquez painted in Seville even before his first visit to Madrid in 1622 can be divided into three groups: *bodegones*, portraits, and religious works. An artist who aspired to a court career had to prove that he could depict people realistically and in a manner befitting their status. If the surviving works from his youthful period are any indication, Velázquez did not find it hard to meet these requirements. Only a few portraits are known from these years and they were probably commissions negotiated by Pacheco. Instead of a portrait, therefore, Velázquez took *The Water Seller* with him to Madrid as proof of his artistic talent.

The first portrait by the artist was a commemorative picture: in around 1620 he painted Father Don Cristóbal Júarez de Ribera (who had died in 1618) in the pose of a kneeling worshipper. Ribera was the godfather of Juana Pacheco, Velázquez's wife, and it therefore seems likely that painter and model had known one another.

Also in 1620, Velázquez painted Mother Jerónima de la Fuente. This Franciscan nun was the founder and first abbess of the convent of Santa Clara in Manila. On her journey from Madrid to the Philippines in 1620, she spent three weeks in Seville. This full-length figure is an impressive depiction of the nun as a formidable missionary and, through the crucifix which she holds like a weapon, as a strong and capable woman. The face with its pursed lips and framed by the nun's habit seems to embody the Latin inscription at the top of the picture: "It is good to await the grace of God in silence." The crucifix in her right hand bears the legend "I shall not rest until God be glorified," rendering the composition with a surprisingly deep sense of space.

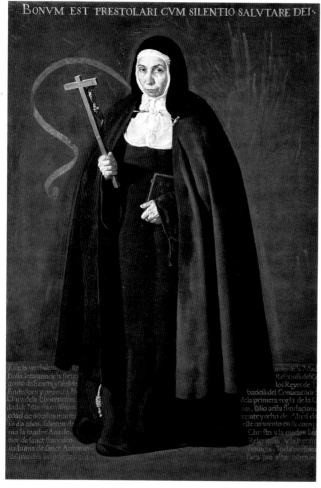

BONVM EST PRESTOLARI CVM SILENTIO SALVTARE DEI·

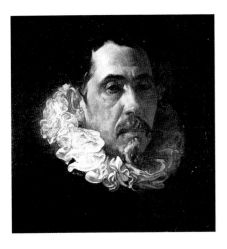

Left:
Francisco Pacheco,
Man with Ruff
1620–1622
Oil on canvas
41 x 36 cm
Madrid, Museo del
Prado

Below:
**Don Cristóbal
Juárez de Ribera**,
1620
Oil on canvas
207 x 148 cm
Seville, Museo de
Bellas Artes

Velázquez was perfectly able to put into practice his father-in-law's doctrine of the "true imitation of nature" as the basis of all good painting.

In the course of his distinguished career Velázquez was to extend still further his abilities in the field of portrait painting: the many pictures of the royal family which he painted as court artist to Philip IV would establish Velázquez's reputation as one of the greatest of all 17th century portraitists.

After these two life-sized portraits, and probably in the same year, Velázquez painted a half-length portrait of a man with a ruff.

The skillful play of light and shadow lends an impressively lifelike quality and intensity to a face not yet touched by the effects of age. The ruff is painted in vigorous brushstrokes and serves to contrast the man's face with the background.

The wearing of such splendid *gorguera*, or frilled collar, was forbidden by royal decree in Spain in 1623, but by and large it was only in Madrid that this strict dress code was followed. The figure depicted here has sometimes been thought to be Francisco Pacheco. Since the outbreak of the Thirty Years' War (1618), however, Velázquez's former teacher had been a censor in the service of the Inquisition and it is unlikely that he would have allowed himself to be pictured wearing a fashion accessory reviled in such circles. This portrait shows that

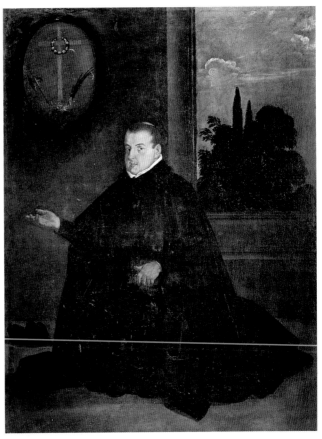

Religious Paintings

In the 17th century it was standard practice for artists in the Catholic city of Seville to paint religious subjects; indeed, themes depicting Biblical stories were the staple of European painting as a whole. It is all the more surprising, therefore, that only seven religious images by Diego Velázquez are known from his early period, even though the piece he painted for his master craftsman's examination was a Biblical history picture (the exact subject is not known) which earned him the title of "Master of Religious Painting." There is no mention, either, of paintings on religious subjects in the writings of his two biographers, Pacheco and Palomino.

Nevertheless, in around 1619 Velázquez painted the *Virgin of the Immaculate Conception*, an impres-

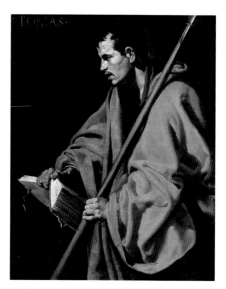

Saint Thomas, 1618–1620
Oil on canvas
95 x 73 cm
Orléans, Musée des Beaux Arts d'Orléans

St Thomas is among the few religious pictures by Velázquez that still survives. This portrait shows the saint as a half-length figure clad in a brown habit. As Philip IV's court painter Velázquez later focused on portraits of the living and rarely had time for other themes.

Virgin of the Immaculate Conception, ca. 1619
Oil on canvas
135 x 101.6 cm
London, National Gallery

According to Pacheco's theory, the Virgin ought to be represented as a 12-year-old girl with her head surrounded by a wreath of 12 stars. She is pictured here standing on the moon in front of an ochre sun surrounded by white clouds. The model for the painting was probably Pacheco's daughter, Juana, whom the painter married shortly after the picture was completed.

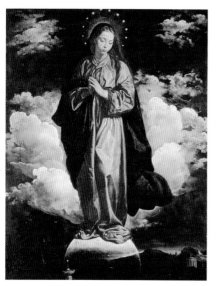

sive religious work that combines three essential features: the theme of the dogma of the Immaculate Conception (a highly controversial topic in Seville since 1615); Pacheco's guidelines for representing this theme; and, finally, the young artist's own artistic interpretation of the subject. Pacheco had described the essentials of the Maria Immaculata in his treatise *El Arte de la Pintura*. Velázquez largely kept within these structures, but developed some of his own variations by introducing a reddish sheen into the white robe and eliminating the crown, which was otherwise a standard attribute of the Virgin. Even though the painting's naturalism, and its use of chiaroscuro as well as vivid effects of light and intense coloration, seem at first to run counter to the religious subject matter, they are an eloquent testimony to Velázquez's individual style.

The similarities of scale, theme, provenance and date all seem to imply that *St John the Evangelist on the Island of Patmos* was painted as a pendant to *Virgin of the Immaculate Conception* – though this argument is undermined somewhat by the different proportions of the two works. Pacheco's guidelines have clearly been adhered to in *John on Patmos*, and this can be confirmed by comparing the work with a drawing by Pacheco on the same theme. In structuring his painting, Velázquez followed his former master exactly, but rejected the older man's exaggerated idealism in favor of a marked naturalism. Only the decorative elements of the painting have changed: Velásquez does not include the eagle that Pacheco places at the side of his saint.

In his early religious paintings Velázquez experimented with the possibilities of chiaroscuro which he had learned from Caravaggio. In addition, religious paintings provided a welcome opportunity to practice the art of composition because these scenes offered a broad range of expressive possibilities. In his depiction of the background the painter was able to exercise his use of perspective, while the figures in the foreground enabled him to capture the specifics of physiognomy. The combination of all these elements placed demands on the compositional skills of painters. In his later work Velázquez was to refine the individual elements of the composition while modifying his motifs.

Francisco Pacheco
Saint John on Patmos, 1599
Drawing on paper
London, British Museum

Below:
Saint John the Evangelist on the Island of Patmos ,
ca. 1619
Oil on canvas
135.5 x 102.2 cm
London, National Gallery

This image of Saint John the Evangelist was probably painted by Velázquez as a pendant to his *Virgin of the Immaculate Conception*. The saint is shown seated in front of a tree and recording in the open book on his lap his vision of a woman and a dragon in the firmament. Based on a copperplate engraving by the Dutch artist Jan Sadeler from the late 16th century, Velázquez's version focuses on a smaller section of the scene and moves it further into the foreground.

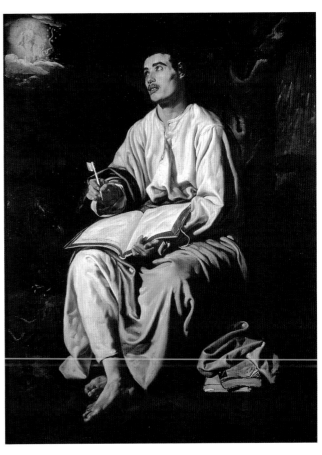

The Court Painter

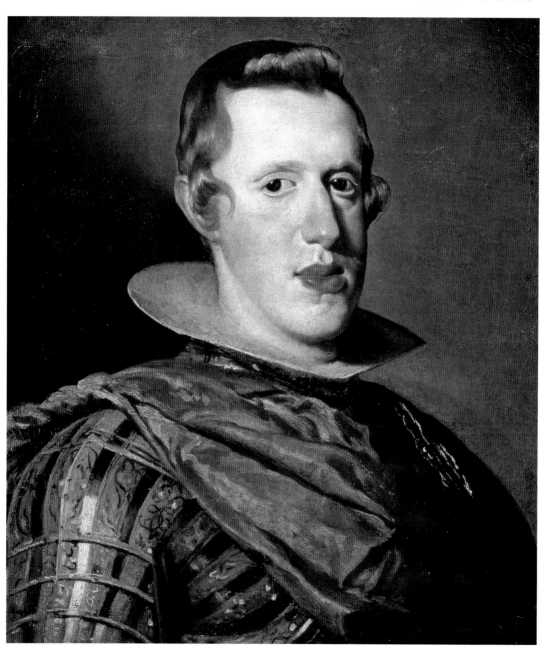

Velázquez's greatest wish, to paint the portrait of Philip IV, led him to Madrid in 1622 and 1623. In spite of the support which he received from his teacher and father-in-law, Francisco Pacheco, as well as from other notables, it was only on his second attempt that the young artist achieved his goal through the offices of the Duke de Olivares. His brilliant career at court overshadowed everything he had previously achieved. Velázquez was given leave to paint the portrait of the young monarch, and he was subsequently appointed fourth court painter. In 1627 he won a painting competition on the subject of the Expulsion of the Moriscos and earned the title of Gentleman Usher. After that he lived and worked in the palace and was awarded a generous stipend. The king's art collection, one of the best in the world, offered the young painter an excellent opportunity for study. In 1628 he met the Flemish painter Peter Paul Rubens, who was attending the Spanish court as an envoy for the second time.

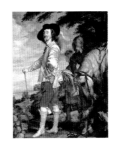

Charles I of England, ca. 1630

Peter Paul Rubens, ca. 1630

1623 The Islamic ruler Abbas I conquers Baghdad.

1624 Cardinal Richelieu becomes the leading minister of Louis XIII; he calls for an Absolutist state and has a lasting influence on French foreign policy.

1625 Charles I becomes King of England. Christian IV of Denmark intervenes in the Thirty Years' War: Danish–Dutch War (until 1630)

1626 Tilly defeats Denmark's Christian IV. St. Peter's basilica in Rome is consecrated. Dutch painter Jan Steen is born.

1628 In the Petition of Rights the English parliament demands that it be the only body with the authority to levy taxation, and that the citizenry have the right to the law's protection.

1622 Velázquez journeys to Madrid with the aim of becoming Philip IV's court painter. The attempt to win the king's favor is initially unsuccessful.

1623 Second journey to Madrid. The influence of the Duke of Olivares enables Velázquez to paint the portrait of Philip IV and on 6 October he is appointed court painter.

1627 Velázquez wins a painting competition organized by the king and is rewarded with the title of Gentleman Usher. Beginning of his career at court.

1628–1629 Velázquez paints his *Bacchus*. The king greatly admires the work and he rewards the artist with a trip to Italy.

Opposite:
Philip IV in Armor, ca. 1628 (detail)
Oil on canvas, 57 x 44.5 cm
Madrid, Museo del Prado

Right:
Head of a Stag, 1626–1627
Oil on canvas, 58 x 44.5 cm
Madrid, Museo del Prado

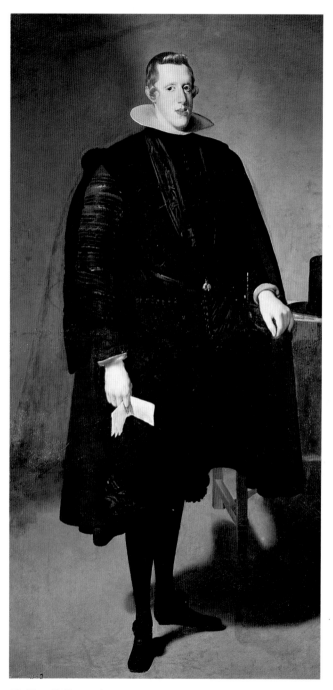

At the Court of King Philip V

In April 1622 Velázquez left his hometown of Seville on a journey to Madrid; his aim was to see the Escorial palace and the paintings that were housed there. He also hoped to use the court contacts of his teacher Pacheco to gain a commission to paint the king's portrait.

Philip IV, the son of Philip III and Margaret of Austria, was born on 8 April 1605 and ascended to the Spanish throne on 31 March 1621 after the sudden death of his father. The new monarch was just 16 and poorly prepared for his leading role as the ruler of one of the most powerful nations in Europe.

Affairs of state were therefore initially in the hands of Philip's favorite Gaspar de Guzmán, Count-Duke de Olivares, who as Prime Minister did his best to exclude the young king from his own country's political life. In 1643 the Duke finally lost his grip on political power due to the intrigues of his equally ambitious nephew, and he was banished from Madrid.

When Velázquez arrived in the capital Don Juan de Fonseca, the Canon of Seville Cathedral and chaplain to the king, made an unsuccessful attempt to present the artist to the royal court.

The Duke de Olivares, who had excellent contacts in Seville, recognized Velázquez as one of the city's most gifted young painters and for

Top:
Rodrigo de
Villandrando
**Prince Philip and
Soplillo**, 1619–1620
Oil on canvas
204 x 110 cm
Madrid, Museo del
Prado

Just before Philip IV's
ascension in 1621
Velázquez's
predecessor at court
painted this portrait of
the future monarch.

Right:
El Escorial, photo

The palace was built
by Juan Bautista de
Toledo and Francisco
de Herrera between
1563 and 1584.

Opposite:
Philip IV, painted in
1623, reworked 1628
Oil on canvas
198 x 101.5 cm
Madrid, Museo del
Prado

many years he was the artist's most influential patron at the royal court.

The Duke de Olivares summoned Diego Velázquez to the court in spring 1623 after Rodrigo de Villandrando, a court artist, had died the previous December; de Villandrando had painted Philip IV's portrait before the king had succeeded to the throne. By the summer Velázquez had been given permission to paint the royal portrait and his efforts met with resounding success. The young Andalucian was given the right to settle permanently in Madrid, receiving the privilege of being the only artist allowed to portray the king. Velázquez moved into the Palacio Real where he also set up his studio.

The other court painters – Vicente Carducho, Eugenio Craxi, Bartolomé González and Angelo Nardi Velázquez – soon launched an attack on Velázquez, however, fearing the serious competition he represented. In order to put an end to the dispute, Philip IV put together a jury in 1627 to judge a painting competition on the subject of the Expulsion of the Moriscos. Velázquez emerged the victor and was awarded a number of accolades including appointments as Gentleman of the Bedchamber and Gentleman Usher.

Diego Velázquez's early years at the court brought him high honors which his biographer and father-in-law, Francisco Pacheco, knew how to describe in fitting language: "The liberality and affability with which Velázquez is treated by such a great Monarch is unbelievable. He has a workshop in the King's gallery, to which His Majesty has the key, and where he has a chair, so that he can watch Velázquez paint at leisure, nearly every day."

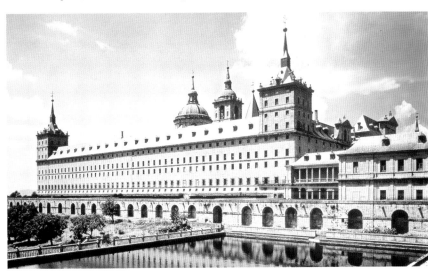

Spanish Art and Culture in the 17th Century

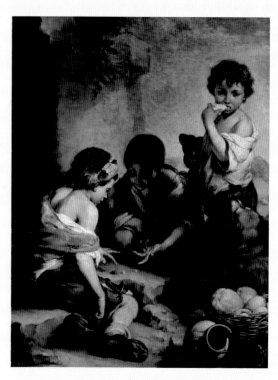

While Spain underwent an era of political, economic and social decline in the 17th century and its status as a great power began to crumble, the country's culture continued to scale previously unattained heights; for a while, at least. The most important reasons for this seeming contradiction lay in the efforts made by the king to conceal the weak position of the court by an ostentatious promotion of

Bartolomé Estéban Murillo
Children Playing,
ca. 1670
(detail)
Oil on canvas
146 x 108.5 cm
Munich, Alte Pinakothek

the arts. Artists were increasingly given political roles in the state and were organized into associations whose purpose was to glorify the Spanish throne. Palaces such as Buen Retiro

(pp. 54–55) were extended and renovated for the king. The interiors and furnishings of state buildings were designed in the Baroque style to emphasize the pomp and grandeur of courtly society; Velázquez made important contributions to this work. A Golden Age – a concept borrowed from antiquity to describe the pinnacle of a country's cultural achievements – began in Spain towards the end of the 16th century.

Spanish painting of the 17th century is today generally associated with the names of a small number of painters. Besides Velázquez and Zurbarán the best known are Bartolomé Estéban Perez, called Murillo, (1618–1682) and José de Ribera (1591–1652). Murillo is considered the main exponent of the Seville school. Although he came from the same city as Velázquez and was exposed to the same artistic influences, the work of these great masters is fundamentally different. Velázquez turned to

Selma Fernando, after
Jimeno Raffael
Lope de Vega, 1780–1810
Print
Paris, Bibliothèque
Nationale

Juan de Jauregui y Aguilar
Miguel de Cervantes, 1600
Oil on canvas
60 x 70 cm
Madrid, Royal Academy of
Languages

portraiture at an early age in order to provide a boost to his career at court; Murillo, on the other hand, moved in the opposite artistic direction, painting pictures focusing on religious and moral subjects. Murillo's themes were drawn from the lives of common people and the poor, inspired by a

profound sense of faith. Another outstanding contemporary of Velázquez was José de Ribera. Although Ribera spent most of his life in Naples, he never lost contact with the artistic life of his homeland. Ribera's painting was at first strongly influenced by Caravaggio's chiaroscuro technique (pp. 12–13). Although his pictures show faces marked by fear and terror, in later years both the color and the content of his work

Francisco de Goya
Village Bullfight,
1812–1819
Oil on canvas
45 x 72 cm
Madrid, Academia de
S. Fernando

became lighter and less grave. Velázquez called on Ribera during a visit to Italy and bought several of his paintings for Philip IV's collection. Spanish literature during this period was dominated by three names: Miguel de Cervantes (1547–1616), Lope de Vega (1562–1635) and Calderón de la Barca (1600–1682). Cervantes was a critic of the contemporary fashion for knightly romances and in *Don Quijote de la Mancha* he created a work of great humanity and stylistic beauty. In the more than 1,000 plays that flowed from his pen, de Vega fused comedy and tragedy and in the process virtually invented Spanish theater. Calderón was a typical

José de Ribera
The Club-footed Boy, 1642
Oil on canvas
164 x 95 cm
Paris, Musée du Louvre

representative of the Baroque, a movement perhaps best embodied in his play *Life, a dream*. The bullfight, an example of popular culture performed throughout the country that is still peculiar to Spanish folklore today, developed from weapons training and the festivities of the aristocracy. Francisco de Goya was later to make the bullfight the theme of several of his paintings. As court painter to Philip IV, Velázquez made significant contributions to the cultural life of Spain and the official titles bestowed on him at court were evidence of the recognition of these achievements.

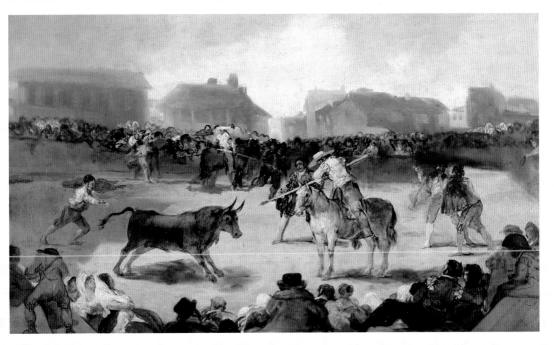

Rubens at the Spanish Court

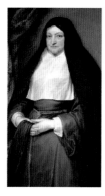

Anthony van Dyck
The Infanta Isabella Clara Eugenia,
ca. 1630 (detail)
Oil on canvas
117 x 102 cm
Paris, Musée du Louvre

Peter Paul Rubens
Birth of the Milky Way, 1628 (detail)
Oil on canvas
181 x 244 cm
Madrid, Museo del Prado

In 1628 the Flemish painter Peter Paul Rubens arrived in Madrid as an envoy, a position given him on the basis of his involvement in successful political negotiations at the Spanish court in 1603.

Rubens' task was to mediate between Spain and Charles I of England, whose portrait Velázquez had painted in Madrid in 1623 when the future monarch was still the Prince of Wales. Rubens was to furnish the king with a report on negotiations conducted between the Infanta Isabella, Governor of the Netherlands, and the English. In addition, Rubens had been commissioned to present several of his own paintings to the Spanish king as a gift from Isabella. Philip IV received these presents with great enthusiasm and had them hung in the New Hall

of the palace. The Flemish painter had also been requested by the Infanta to portray the king and his family; the great equestrian portrait of Philip that resulted was then displayed in the New Hall in place of Velázquez's own royal portrait. Although this gave the Spanish artist ample opportunity to develop his own ideas for a monumental equestrian portrait of the king, Rubens' preferential treatment was also an affront to Velázquez. It appeared that no one was interested in upholding Velázquez's monopoly on royal portraiture: at the time, Rubens was principally engaged in painting the portraits of the royal family in a studio that had been specially set up for him, while in other work he copied several of Titian's paintings.

In spite of this rivalry, Velázquez used the occasion to observe the Flemish master at work. According to Pacheco, Velázquez was the only one of the court artists with whom Rubens communicated. The two men had already corresponded with each other prior to Rubens' arrival in Spain, and Rubens praised the work of his Spanish friend and colleague both for its quality and modesty. They would have journeyed to the Escorial together to view the famous monastery of San Lorenzo el Real and would have admired the numerous art works of its collections. In particular, paintings by the Italian artist Titian (pp. 42/43) had a lasting effect on both men, an influence that Rubens would express in his *Birth of the Milky Way*.

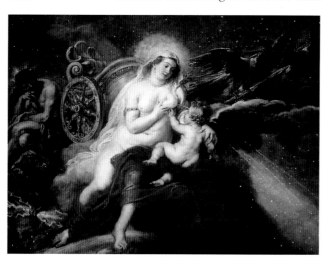

The Flemish painter's effect on Velázquez in terms of subject matter was to be short-lived; eventually, the Spaniard turned away from religious pictures such as *Christ and the Christian Soul* in favor of portrait painting.

Though he used some of the essential features of Rubens' work in his portraits of the country's rulers, Velázquez's interests were concentrated on the character and position of his sitters.

After only nine months at the Madrid court, Rubens was ordered to London though not before he was knighted by the Spanish king.

Velázquez was therefore the court's premier painter once again.

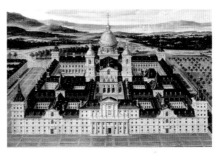

Rubens had left a deep impression on the young Spaniard, however, and the influence of the Flemish master can be clearly detected in Velázquez's oeuvre.

Monastery of San Lorenzo in the Escorial
Contemporary print

This engraving shows the monastery of San Lorenzo in which artworks from the collection of Philip IV were housed. Velázquez toured this collection together with Rubens, and one can well imagine the discussions of the two painters on such an occasion. Visits by artists were intended to inspire them to new achievements.

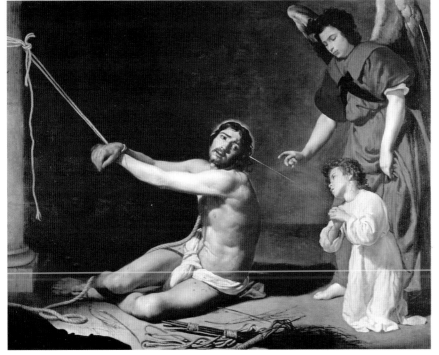

Christ and the Christian Soul,
ca. 1629
Oil and canvas
165.1 x 206.4 cm
London, National Gallery

This painting is among the most sensitive works painted by Velázquez. The sorrowful gaze of the bound Christ is underscored by the kneeling child on the right of the picture; he looks with pity on his suffering redeemer while the angel to his right reveals Christ's identity. The symbols of the Passion were arranged by Velázquez in the picture's foreground.

Bacchus

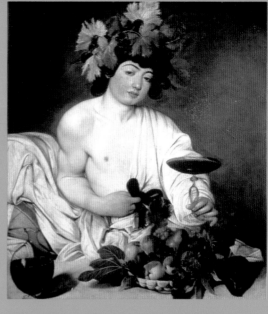

Bacchus was the son of Jupiter, the king of heaven, and was worshipped as the Roman god of wine and fertility. During these rites his disciples would abandon their daily activities and follow their god through the forests in a state of intoxication and ecstasy. Only women, so-called Bacchantes, took part in these processions, festooning themselves with ivy and vine-leaves and dancing for Bacchus who was in the form of a bull or he-goat. Depictions of the god underwent a gradual change in the fine arts, however: in the Classical age he was characterized as an older, bearded man, but with the passage of time Bacchus came to be represented as a naked and rather plump youth. During the Renaissance and Baroque eras depictions of the god became an occasion for work that reveled in sensuality and color. Titian, the leading artistic personality of Venice, depicted his *Bacchanal* of 1518–1519 as a joyous festival taking place in the open air. Caravaggio focused in his depiction of Bacchus on an intimate portrait of one of his contemporaries in classical costume who is seen proffering the viewer a glass of wine. At first glance Velázquez's *Bacchus* of 1628–1629 seems to have attempted a fusion of Caravaggio's and Titian's pictures: as with Titian the gathering takes place in the open, while the figure

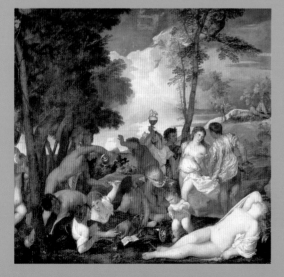

of the half-naked god with his wreath of vine-leaves, as well as his face and hairstyle, relate the work directly to Caravaggio's painting of 1593–1594. The figure to the left of Velázquez's *Bacchus* with his large ears looks like one of the Roman god's companions, a satyr. The other characters are simple folk – shepherds, soldiers and laborers – with weathered faces. Their circular arrangement around the god provides an opportunity to see them in a more differentiated light and it sets up a

Titian
Bacchanale, ca. 1520 (detail)
Oil on canvas
175 x 193 cm
Madrid, Museo del Prado

Michelangelo Merisi da Caravaggio
Bacchus, 1593–1594
Oil on canvas, 95 x 85 cm
Florence, Galleria degli Uffizi

network of contrasting gestures and lines of sight. A comparison of the image with the classical literary tradition associated with the god, especially in Ovid's *Metamorphoses*, shows just how unusual Velázquez's treatment of Classical mythology is. The Roman poet described the festivals in honor of the god Bacchus – Dionysus in Greek mythology – as being celebrated exclusively by women. During these rites the god was surrounded by a swarm of satyrs and nymphs. Velázquez,

... I see his clothing, his face and his gait: I perceive nothing in him that is mortal.

Ovid, Metamorphoses III, 610–612

however, depicts only men attending the god, who is seated on a barrel. Grouped in a circle and dressed in everyday clothes, they cluster around the garlanded god whose white blouse and robe – purple in Ovid's description – are bunched round his waist to reveal the youth's naked torso. Because of the unusual composition – unrelated to work by any other artist on the subject – this painting has given rise to a wide range of interpretations. It has been seen as a parody of the gods of Antiquity, as a theatrical performance, and as a profane carnival.

As in a Dutch copperplate engraving on the subject, this Bacchus seems more like a figure who has just liberated a group of soldiers. This might explain why the god is celebrating his rites of intoxication with unprepossessing male companions rather than with women, as in the mythological story.

The picture is a puzzle that has yet to be solved, but this mystery only increases the fascination it holds for the viewer.

Bacchus, 1628–1629
Oil on canvas
165 x 225 cm
Madrid, Museo del Prado

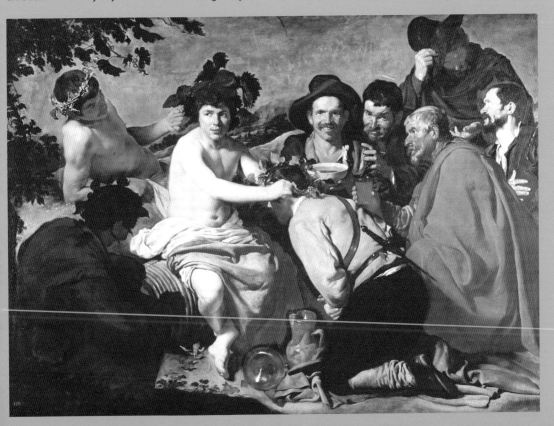

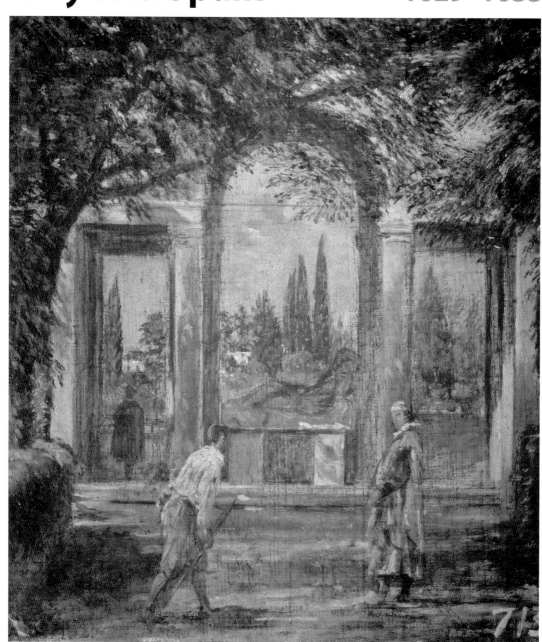

In August 1629 Velázquez embarked on a voyage from Barcelona to Genoa. At this time Italy, and especially Rome, were popular destinations for artists: the sculptures of the ancient city were seen as silent witnesses of the Classical age, and the Renaissance paintings – along with more contemporary developments in art – offered abundant opportunities for study. Velázquez traveled at first to Milan and Venice where he bought pictures on behalf of Philip IV and copied works by Tintoretto and other masters. After a detour to Ferrara he went to Rome, where he spent a year studying the frescoes of Michelangelo and Raphael. The focus of his work during this period was on the representation of the naked male body and a new, atmospheric depiction of space. Before returning to Spain in 1631 he paid a quick visit to Naples to see his Spanish colleague, José de Ribera.

Back in Spain, Velázquez painted a few religious pictures before dedicating himself to portraiture once more.

Galileo Galilei, ca. 1636

Rome, Four Rivers Fountain, 1647–1651

1636 Rembrandt Harmensz van Rijn moves from Leiden to Amsterdam.

1632 Jan Vermeer van Delft is born.

1633 After a long interrogation by the court of the Inquisition in Rome, the astronomer Galileo Galilei is forced to recant his thesis that the earth revolves around the sun.

1629 On his way to Italy, Velázquez passes through Granada and draws the city's cathedral.

1629–1631 First journey to Italy. In Venice he studies the works of Tintoretto and Titian and the frescoes of Michelangelo and Raphael in Rome which inspire his paintings *Apollo in the Forge of Vulcan* and *Joseph's Blood-stained Coat Brought to Jacob.*

1631 Back in Madrid, Velázquez paints the portraits of the royal family.

1632 Paints *Christ on the Cross.*

Opposite:
Villa Medici, 1630 (detail)
Oil on canvas
44.5 x 38.5 cm
Madrid, Museo del Prado

Right:
The Cathedral of Granada, 1629
Drawing on paper
80 x 90 cm
Madrid, Biblioteca Nacional

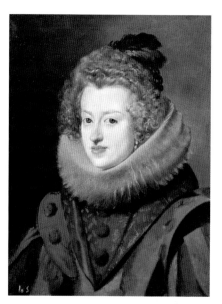

The Infanta Doña Maria, Queen of Hungary, ca. 1630
Oil on canvas
59.5 x 45.5 cm
Madrid, Museo del Prado

The portrait of the Infanta Doña Maria, later to become Queen of Hungary, was painted by Diego Velázquez during his first stay in Italy in 1630. The artist was probably responding to a commission from Philip IV, who wanted a reminder of his sister.

Below:
Raphael Santi, called Raphael
The School of Athens, 1509–1511 (detail)
Fresco
Rome, Vatican, Stanza della Signatura

First Journey to Italy

After the accolades Velázquez received from the king for his *Bacchus* of 1629, he was given royal leave and the finance to travel to Italy. Velázquez was not simply one of the many anonymous artists who made the pilgrimage to Italy in search of inspiration. Instead, he was equipped with royal letters of introduction and recommendation, his itinerary known to diplomatic representatives and the Italian courts, and at every point along his journey Velázquez was accorded the respect befitting his status as the court painter.

On 10 August 1629 he boarded a Spanish king's Genoa-bound ship in Barcelona with the Genoese general Ambrogio Spinola. He passed through Milan and then ventured on to Venice in order to broaden his knowledge of Titian and to copy Tintoretto's *Last Supper*. He was a guest at the home of the Spanish envoy to the Venetian Republic but political tension in the city – the result of conflict with Spain – cut his stay short. On his way to Rome he met Cardinal Giulio Sacchetti, a well-known patron of the arts, and in Cento he may have encountered the painter Guercino, who was famed for his realistic depictions of natural light. Finally, he arrived at the Vatican in order to study the greatest works of the High Renaissance. In Rome he was received by the influential Cardinal Francesco Barberini – a nephew of Pope Urban VIII – who invited him to use apartments in the Vatican palace. Velázquez was also given permission to make sketches of the frescoes by Michelangelo and

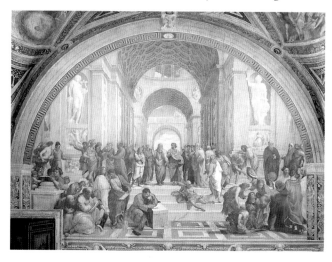

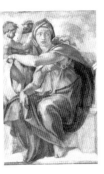

Michelangelo
Buonarroti
Sybil of Delphi, 1509
(detail), Fresco
Rome, Vatican, Sistine
Chapel

Cardinal Barberini
helped to obtain
permission for
Velázquez to study
Michelangelo and
Raphael's frescoes in
the Sistine Chapel.

**The Villa Medici
Gardens, Rome:
Grotto-Loggia
Façade**, 1630
Oil on canvas
44.5 x 38.5 cm
Madrid, Museo del
Prado

A surprising piece for
two reasons: an
unusual theme for
Velázquez and a
treatment of color
that recalls the
Impressionists. The
group of artists
were instrumental
in invigorating
European painting at
the end of the 19th
century with their
free use of color and
bold brushstrokes.

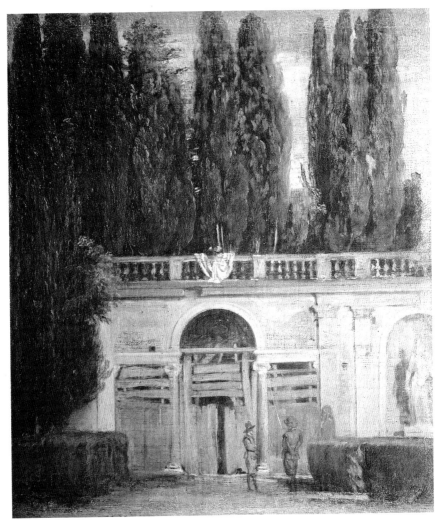

Raphael in the Vatican, an exercise that influenced his future work.

In the summer of 1630 Velázquez moved into apartments in the Villa Medici where, surrounded by a vast art collection, he was able to escape the worst of the summer heat. In autumn 1630 he visited his Spanish colleague, José de Ribera, in Naples where he painted the portrait of Philip IV's sister the Infanta Maria, who was on her way to join her husband, Ferdinand III of Hungary.

In January 1631 Velázquez returned to Madrid, where the king eagerly awaited him, and where he was soon commissioned with new royal portraits.

Titian – the Great Example

Titian
**John Frederick the
Magnanimous**, 1550–1551
(Detail)
Oil on canvas
103.5 x 83 cm
Vienna, Kunsthistorisches
Museum

The Venetian artist Titian
had a huge influence on
the technique and thematic
choice of Diego Velázquez,
who had the opportunity of
studying works by the
Italian master in the royal
collection in Madrid and
while he was traveling in
Italy. Tiziano Vecellio, better
known as Titian, was born
in Pieve di Cadore in 1477
and died in Venice on 27
August 1576. His travels
took him to Padua, Mantua
and Rome. After an
apprenticeship with Gentile

and Giovanni Bellini, Titian
worked with Giorgione
(1477–1510) whose lyrical
pictures he studied closely
(p. 81); the two painters
collaborated on several
pictures while in Venice.
Giorgione's paintings are
renowned for their unique
atmosphere – often
referred to as an Arcadian
atmosphere – which was
effected through an
extraordinarily sensitive
treatment of light and color.
While still young, Titian saw
European painting make
the transition from the
Renaissance to the Baroque.
His *Ascension of the Virgin*
from 1518 was composed
in stark chiaroscuro
contrasts, a typical feature
of Baroque painting that
Velázquez also made use of
in his own work.
Titian worked almost
exclusively in Venice but he
also painted for Emperor
Charles V and his son Philip
II, as well as for Pope Paul III
and many other dignitaries.
By around 1530 his
diplomatic skill and his
ability to convey a sense of
humanity in his pictures
while still meeting the

representational
requirements of his clients,
secured him the reputation
of Europe's greatest
portraitist. In 1548 and
again in 1550 Titian was
received by Charles V, who

was holding an Imperial
Diet in Augsburg. Princes
and various dignitaries
from throughout the
Empire were in attend-
ance and many of them,
such as John Frederick the

Left:
Giorgione
The Tempest, ca. 1506
Oil on canvas
82 x 73 cm
Venice, Galleria
dell'Accademia

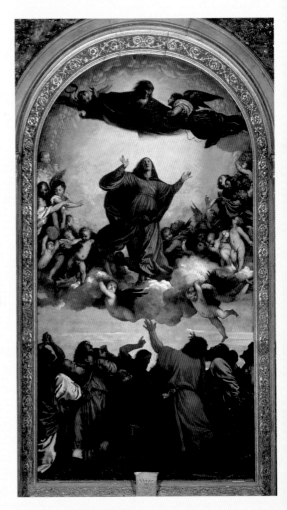

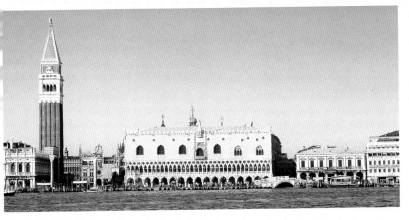

View of St Mark's Square in Venice with the Campanile (left) and the Palace of the Doge, Photo

Magnanimous, Elector of Saxony, wanted Titian to paint their portraits. Titian's subject matter, and his ability to depict a historical event dramatically while still retaining spontaneity of expression, formed the basis of his greatest triumphs. These qualities were still able to hold Velázquez and his colleagues in awe over a century later. The Venetian's intense color scheme and the expressiveness of his figures left their mark on European painting for generations. Titian was also one of the first artists to paint

Opposite:
Titian
Ascension of the Virgin, 1516
Oil on canvas, 690 x 360 cm
Venice, S. Maria Gloriosa dei Frari

children's portraits, a genre of which Velázquez also proved himself a master. Occasionally in his later portraits, Titian did away with all extraneous decorative devices in order to allow the face of the sitter to "speak" more clearly, as in his famous self-portrait of 1562. Velázquez's portraits are similarly bereft of allegorical ornamentation. Both painters were skilled at capturing the character of the sitters in their facial expression. This skill made the people in the paintings appear so lifelike that the viewer has the impression of gazing upon flesh and blood rather than a mere image on a two-dimensional surface. Titian used a varnish technique that allowed up to 30 different layers of various thicknesses to be applied to the surface in order to achieve the effect of depth by means of light and shadow. His pictures are also characterized by their use of rapid brushstrokes;

yet another technique later taken up by Velázquez as well. Like the Venetian, Velázquez applied color in thick layers to the canvas (the technical expression is "pastose"). This, combined with a rapid technique, allowed the traces of heavy brushstrokes to be clearly seen on the canvas. Titian's painting style influenced not only Velázquez but many other artists until as recently as the 19th century.

Titian
Self-portrait, 1562
Oil on canvas, 96 x 75 cm
Berlin, Staatliche Museen zu Berlin, Preußischer Kulturbesitz, Gemäldegalerie

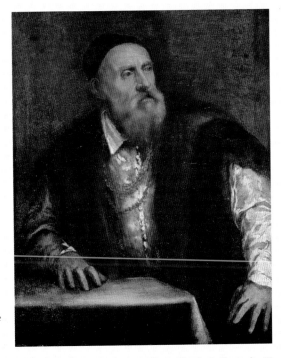

The Count-Duke de Olivares, ca. 1630
Oil on canvas
200 x 100 cm
Madrid, Varez Fisa Collection

In this work Velázquez captured the Count-Duke in a proud pose.

Artistic Orientation

Velázquez's technique was not uniform but changed according to the degree to which he was stimulated by his study of other artists, whether established or recent ones. Developments that were only hinted at in his work or were completely lacking prior to his trip to Rome – then the artistic heart of Europe – became much more prominent after he returned to Madrid. Freed from the obligation to paint portraits, Velázquez soon dedicated himself to painting two historical pictures shortly after arriving in the Eternal City. These paintings – *Apollo in the Forge of Vulcan* and *Joseph's Blood-stained Coat Brought to Jacob* – dealt with themes from ancient mythology and the Old Testament. With similar formats and matching pictorial structures, they are considered a pair. Velázquez chose to paint both these pictures, without a commission; they were later purchased by Philip IV for his pleasure palace of Buen Retiro. These works were, it seems, the result of the painter being attracted by a theme for which his court duties otherwise left him no time. New elements appear in these paintings as the offshoot of Velázquez's intensive studies of the art he saw in Rome: the figures are graduated within the pictorial space to create a sense of depth, and the slim, largely naked

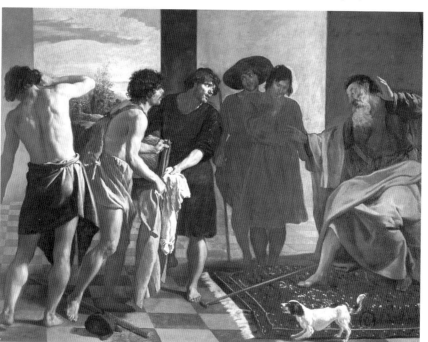

Joseph's Blood-stained Coat Brought to Jacob, 1630
Oil on canvas
223 x 250 cm
Madrid, Monastro del Escorial

Here it is the sons themselves – rather than shepherds as in the Biblical version – who fake their brother's death by presenting his blood-smeared coat to their father. Painted during Velázquez's travels to Italy, this picture recalls frescoes by Michelangelo and Raphael in the Vatican. The treatment of color in his work owes much to Titian.

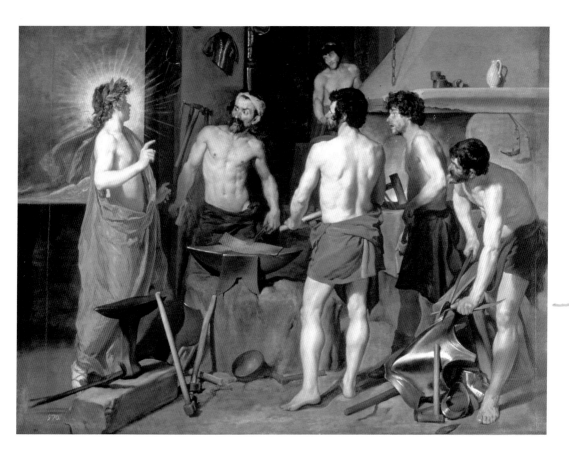

bodies are linked to each other within the composition despite the variety of their positions and gestures.

In his early pictures Velázquez preferred dark colors, but he gradually began to work with the brighter end of the spectrum. These modifications in color were complemented by an emphasis on light which, through a dramatic use of chiaroscuro, brought the figures to the foreground. Velázquez's interpretation of historical themes by using elements drawn from the world of daily life can be seen, for example, in the *Forge of Vulcan* in the way the two gods confront each other: the youthful god of art, Apollo, appears in the forge in order to tell the frail-seeming older god of the unfaithfulness of his wife, Venus. Velázquez's coloration in both pictures is modeled on Titian's work, while his rendering of the naked bodies owes much to Michelangelo's frescoes.

Despite his artistic flowering, Velázquez's duties at court slowly forced the painter to push his own artistic interests into the background in favor of the wishes of his patrons.

Apollo in the Forge of Vulcan, 1630
Oil on canvas
222 x 290 cm
Madrid, Museo del Prado

This historical painting, made during Velázquez's stay in Italy in 1629, was inspired by his study of the works of Titian and the classical frescoes of Michelangelo and Raphael.

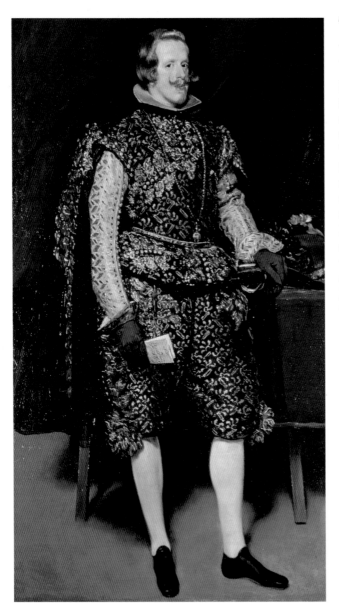

The Spanish Royal Family

In January 1631 Velázquez returned to Madrid, where the king was eager to have his portrait painted again after such a long time. As Velázquez's monopoly on the right to portray the king had been respected during the artist's absence, there was much to be done. In addition, a portrait of the Queen, Isabella of Bourbon, which had been started before his journey to Italy, was still incomplete. Isabella, the daughter of the French king Henry IV, had married Philip, then heir to the throne, in 1615. In October 1929 their first son, Prince Baltasar Carlos, had been born; an event celebrated on a lavish scale.

Velázquez was also expected to portray the prince after his return from Italy. It is of course impossible for a 16-month-old child to pose for a painter holding a sword and staff of command. The artist therefore painted the extraneous elements of the picture first in accordance with the requirements of court etiquette, which dictated that the insignia of the prince's present and future positions be represented. It was only later that he added the child's face. The prince is depicted standing on a podium with a female dwarf close by holding a rattle and an apple in reference to the royal symbols of power, the orb and scepter.

Velázquez's portrait of Philip IV is less a naturalistic depiction of the

Philip IV, ca. 1631
Oil on canvas
199.5 x 113 cm
London, National
Gallery

The king, dressed in brown and silver tones, stands in a room in front of a table. In his right hand he holds a petition which Velázquez has signed with his own name and title.

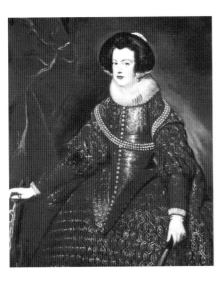

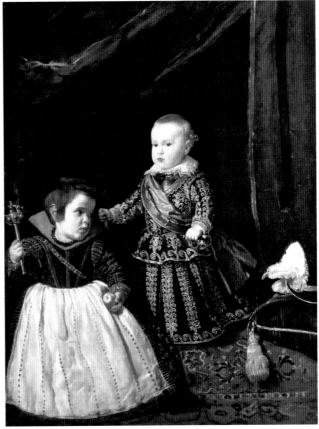

king – who was in reality a delicate and sickly man – than an idealized portrait of royal grandeur. With one hand on his saber and holding a petition in the other, Philip is depicted in a brown and silver brocade suit with a cape; he also wears the Order of the Golden Fleece.

The full-length portrait of Isabella shows her standing, though the work was later cut down to reduce it in size. It was originally intended to be sent, together with a portrait of Philip IV, to the court in Vienna.

The portraits of the royal family painted during Velázquez's time at court are ample evidence of his extraordinary understanding of the potential of the portrait as a genre. His depictions of people capture the character of the sitter often in an unsparing naturalistic style. Thus, while Velázquez's portraits of the royal family may have been idealized depictions, they were also sensitive

Above left:
Isabella of Bourbon,
1632
Oil on canvas
132 x 101.5 cm
Chicago, Art Institute
of Chicago

Above right:
**Prince Baltasar
Carlos with an
Attendant Dwarf**,
1631, Oil on canvas
128.1 x 102 cm
Boston (Mass.),
Museum of Fine Arts

enough to convey the sitter's individual characteristics.

It was precisely this skill that made Velázquez one of the greatest portraitists of the 17th century and a role model for future generations of artists.

Christic on the Cross

In 1628 Jerónimo de Villanueva, one of the most powerful men in the government of the Duke de Olivares, had attempted to initiate proceedings by the Inquisition against his former fiancée, Mother Teresa Valle de la Cerda, who was then abbess of the Benedictine convent of San Plácido in Madrid. In 1632 the schemer himself was officially charged, but he managed to escape prosecution thanks to his position at court. Instead he was sentenced to a symbolic gesture of atonement and it is thought today that Villanueva commissioned Velázquez's *Christ on the Cross* for this purpose; painted in 1632, it was at first hung in the convent of San Plácido. Velázquez's crucifixion scene is modeled on the iconographic tradition of his former teacher, Pacheco, who had called for Christ to be pictured with four instead of three nails in order to achieve a more dramatic stretching of the body. Velázquez's *Christ on the Cross* is, however, anything but a traditional history painting, or a slavish attempt to follow every dictate of the painter's teacher. The austere dignity and beauty of Christ's body in Velázquez's work, with its face partly veiled by hair, is a brilliant combination of all the experiences the artist had absorbed on his journey to Italy. The depiction of the head lowered as a gesture of mercy, on the other hand, is taken from Pacheco while the fine nimbus around the Savior's head and the elegantly clear lines of the wooden beams are Velázquez's own inventions. Given the relatively strict parameters that applied to such iconic pictures, Velázquez's work shows considerable variation. It was obviously planned down to the smallest detail. The plasticity of the body, which combines the clarity of a Classical sculpture with the kind of lifelike quality only achievable in paint, is something Velázquez had particularly admired in Rubens' work. The Flemish artist's painting of the crucifixion had emphasized the naturalism of the body and the drama of the moment by using a dark background. From Rubens Velázquez adopted the central element of the

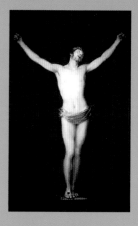

loincloth but did not imitate the crossed feet and raised arms of the earlier work; indeed, the Spanish artist chose a quieter and more representative version of the motif. Francisco de Goya, in his painting on the same theme 150 years later, exaggerated this effect in an almost theatrical way.

Top:
Francisco de Goya
Christ on the Cross, 1780
Oil on canvas
255 x 153 cm
Madrid, Museo del Prado

Left:
Peter Paul Rubens
Christ on the Cross,
ca. 1610 (detail)
Oil on wood
105.5 x 74 cm
Copenhagen, Statens
Museum for Kunst

Opposite:
Christ on the Cross,
ca. 1632
Oil on canvas
250 x 170 cm
Madrid, Museo del Prado

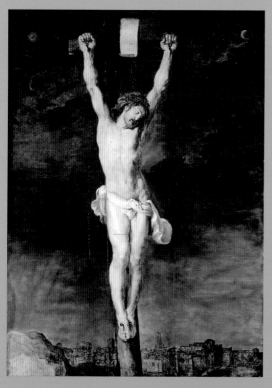

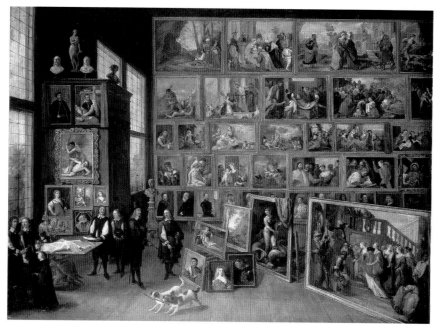

The Working Day of a Court Painter

The tasks of a court painter, particularly at the 17th century Spanish court with its complex internal structure, were not limited solely to the production of paintings. Initially certain duties of state were connected with the office and its various titles, and these could be very demanding. In 1627 Diego Velázquez was sworn in as Master of Ceremonies; from 1634 he was Gentleman of the Wardrobe; in 1642 he became Master of the Royal Bedchamber; and, in 1643, Chief Steward. In the same year he was charged with assisting in the management of royal buildings, and in 1652 he was named Chamberlain of the Royal Palace. This office was enormously time-consuming, and included in its duties was responsibility for all royal festivities. In 1659 he was knighted, becoming a member of the Order of St James. The court painter was also required to ascertain whether the vast number of pictures offered for sale to the royal family were suitable for the court. Velázquez was without a doubt asked for his advice on the purchase of objets d'art and was himself often commissioned to buy paintings. *The Picture Gallery of the Archduke Leopold Wilhelm in Brussels*, painted by David Terniers the Younger, conveys an impression of the great art collections of the day.

No such pictures of galleries are known in Velázquez's work as he was primarily engaged as a portraitist. His models were, however, by no means limited to the king and members of his family – such as the infant prince Baltasar Carlos, whom Velázquez was to paint shortly after his return from Italy in 1631. The highest representatives of the state also sat for the court painter, foremost among them being the Duke de Olivares, who had himself depicted in the dignified form of the equestrian portrait.

To have one's portrait done by the court painter – regardless of whether it was Velázquez or not – was esteemed a great honor; it was, for example, also bestowed upon the respected court buffoon Don Juan de Austria. These portraits were generally court commissions but Velázquez was also able to offer his monarch other pictures for sale which he had made at his own initiative – such as his views of the gardens of the Villa Medici in Rome (p. 38–41).

The Count-Duke de Olivares on Horseback, ca. 1633
Oil on canvas
31.4 x 240 cm
Madrid, Museo del Prado

Philip IV's most powerful politician is immortalized in a regal pose on horseback, a style normally used only for kings.

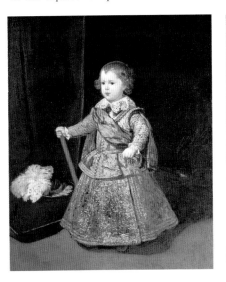

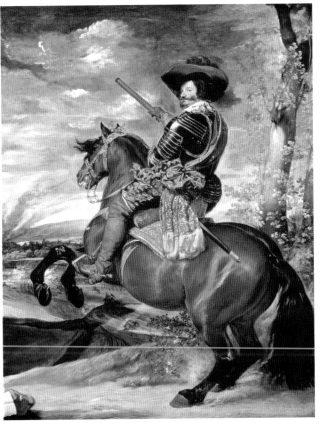

Prince Baltasar Carlos, 1633
Oil on canvas
117.8 x 95.9 cm
London, Hertford House, Wallace Collection

Here the prince with his staff of command and red sash was probably painted on the occasion of the oath of allegiance sworn to him on 7 March 1632. Eyewitness reports suggest the prince wore a so-called *vaquero*, a brocade gown with coat which matches the clothing Velázquez depicted in this painting.

Art and Politics 1634–1636

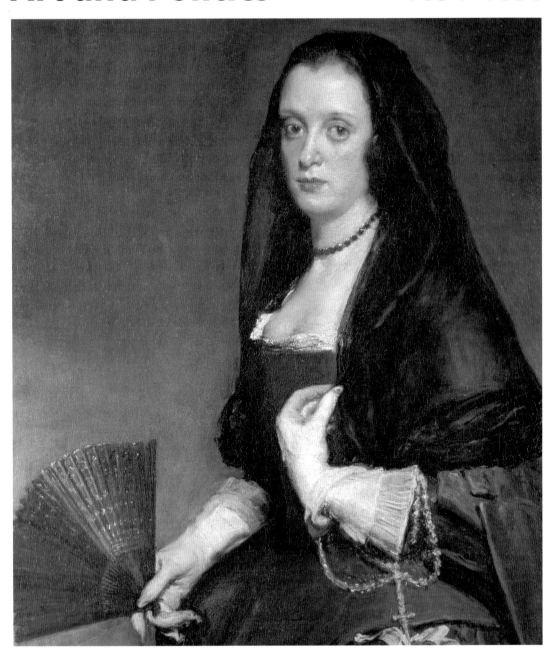

For several years Velázquez devoted most of his time to the completion of politically motivated commissions. He supervised the decoration of the new palace of Buen Retiro and the hunting lodge of Torre de la Parada in the game park of the Pardo, contributing his own paintings for these buildings. For the palace Velázquez painted the royal family on horseback, while for the hunting lodge he depicted the male members of the family as huntsmen. The political aspect of his artistic work was made more explicit when he was required to depict Spanish military victories at a time of quite radical decline in state power. While Spain's political influence was ebbing, Spanish art was undergoing a Golden Age, and Velázquez's work was a major contribution to this brilliant chapter in the country's cultural history.

Cardinal Richelieu, 1635

1635 Beginning of the Swedish–French war.

1636 The Academie Française is founded in France at the initiative of the king's chief minister, Cardinal Richelieu.

1637 The first opera is performed in Venice.

Self-portrait, ca. 1638

1634–1635 Velázquez paints equestrian portraits of the royal family.

1635 Completes the history picture *Surrender of Breda* for the Hall of the Empires in the newly enlarged palace of Buen Retiro.

1636 Extension of the Torre de la Parada hunting lodge. Velázquez's hunting portraits of Philip IV, the Cardinal Infante Don Fernando and Prince Don Carlos form part of the lodge's collection.

Opposite:
The Lady with a Fan, ca. 1635 (detail)
Oil on canvas, 95 x 70 cm
London, Hertford House, Wallace Collection

Right:
Rearing Horse, ca. 1634–1635
Oil on canvas, 305 x 320 cm
Madrid, Palacio Real

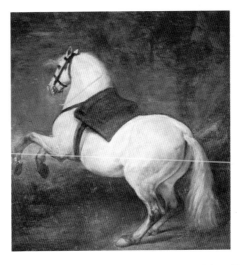

Pietro Tacca
**Equestrian Statue
of Philip IV**, ca. 1635
Bronze
209.5 x 174 cm
Madrid, Plaza de
Oriente

This statue of Philip
IV, commissioned by
the king in Italy, was
inspired by
Velázquez's painting.

Jusepe Leonardo
**Palace of Buen
Retiro**, 1637–1638
Oil on canvas
130 x 305 cm
Madrid, Patrimonio
Nacional

The Equestrian Portraits of the Buen Retiro

In the 1630s massive efforts were made at the Spanish court to redress the decaying political and economic power of the country by encouraging cultural excellence. Under the direction of the Duke de Olivares the Buen Retiro palace was rapidly expanded, enabling the pomp and splendor of the state to be displayed on a hitherto unprecedented scale as a sign of political strength. The interior surpassed all previous standards of royal magnificence. The Hall of the Empires, named after the 24 empires of the Spanish monarchy, served as the most important state rooms. It was here that court ceremonies were held and that the most important pictures highlighting the nation's power and fame were exhibited.

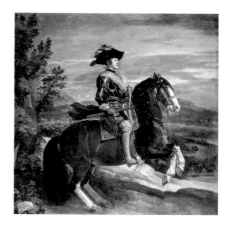

Philip IV on horseback, 1634–1635
Oil on canvas
303.5 x 317.5 cm
Madrid, Museo del Prado

Velázquez chose to depict the horse and king here in profile. Philip IV is performing the *Levade*, one of the figures in the equestrian *haute école*. The artist has achieved a depiction of absolute power: the king is portrayed carrying his staff of office and is wearing the armor and red sash of a military commander-in-chief. The painting shows Philip as both an exceptionally good horseman and ruler.

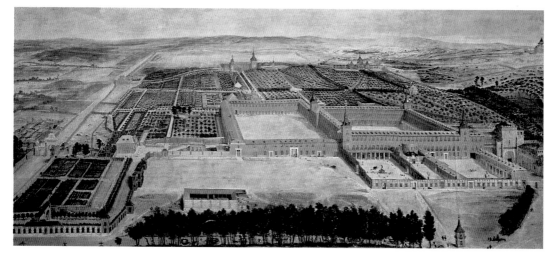

Queen Isabella of Bourbon on Horseback, 1634–1635
Oil on canvas
302 x 311.5 cm
Madrid, Museo del Prado

Monumental equestrian portraits were generally reserved for male rulers, so this painting of the queen is considered most unusual.

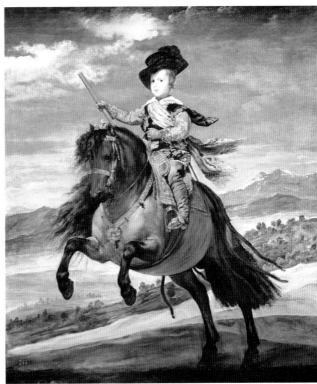

On the east wall hung Gonzalez's equestrian portrait of Philip III (p. 11) and that of his wife, Margaret of Austria. For the west wall Velázquez painted three other equestrian portraits. The pictures of Philip IV and his wife, Isabella of Bourbon, were hung in such a way that the subjects appeared to be riding towards each other while the painting of their son, Prince Baltasar Carlos, was placed between them over a doorway. Velázquez had probably begun work on these pictures before his departure to Italy in 1629; his assistants then completed most of the work before the court painter returned to finish them himself. With his portrait of Philip IV on horseback Velázquez departed from Titian and Rubens' compositions in the royal collection, opting instead for a seemingly arbitrary profile view. A life-size equestrian portrait of a woman – such as that of Isabella of Bourbon – was considered highly unusual. The portrait of the young prince, Baltasar Carlos, was the only piece in this series intended to be hung over a door above the viewer's head. This explains the apparently exaggerated proportions of the horse's belly.

The excellent quality of these pictures underscores the significance and representative function they had in the context of the newly renovated palace.

Prince Baltasar Carlos on Horseback, 1634–1635
Oil on canvas
209.5 x 174 cm
Madrid, Museo del Prado

This portrait's unusual composition was dictated by the position in which it was originally hung, which was above head height. The horse's belly is rendered as seen from below to give it the effect of jumping towards the viewer.

Torre de la Parada

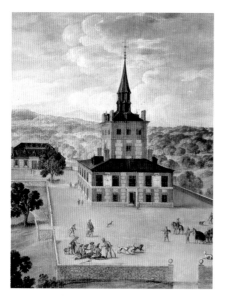

Hunting was a privilege of the nobility and one of Philip IV's favorite pastimes. Such hunts were commonly organized by driving game animals into gigantic enclosures to be killed by sportsmen. In 1636 the king decided to rebuild the modest hunting pavilion of Torre de la Parada, near Madrid, and convert it into a lodge. Peter Paul Rubens, the famous Flemish Baroque painter, was commissioned to prepare pictures using motifs from Classical mythology – generally Ovid's *Metamorphoses* – for the new interiors of Torre de la Parada. Within 18 months he had made around 60 sketches in oil as designs and these were then largely painted by other artists. Velázquez supervised the decorations as well as providing some of his own paintings. He made three life-size hunting portraits of Philip IV, his son Baltasar Carlos and the brother of the king, Don Fernando. The hunting portraits depict moments captured in the private lives of royalty but they all adhere to the requirements of courtly portraits. The vertical compositions have a similar structure: all three show figures dressed in brown hunting jackets standing in front of a tree that extends out beyond the edge of the frame, and each of the subjects is provided with the typical attributes of the hunt: a dog and a gun. Contrary to what might be supposed these pictures were not painted in the open but, as

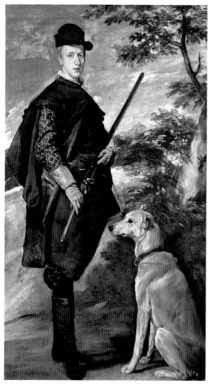

Felix Castello
The Torre de la Parada, 1637 (detail)
Oil on canvas
Madrid, Museo Principal

In 1636 Juan Gómez de Mora was commissioned to extend the hunting pavilion into a hunting palace suitable for state functions. Velázquez hung the three hunting portraits in the renovated building as early as 1638.

The Cardinal Infante Don Fernando as Huntsman, 1632–1633
Oil on canvas
191.5 x 108 cm
Madrid, Museo del Prado

Don Fernando had been appointed Cardinal at the age of 10. In 1632 he left Madrid and after the death of his brother Don Carlos in 1634 he remained in Brussels as Governor of Flanders. Velázquez painted his only portrait of the young Cardinal by copying his face from a picture made by Rubens in 1628.

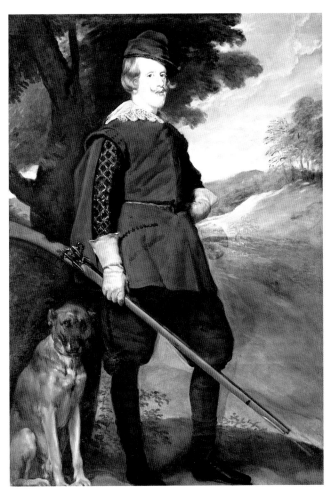

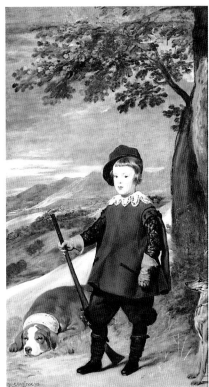

Prince Baltasar Carlos, 1635–1636
Oil on canvas
191 x 102 cm
Madrid, Museo del Prado

This painting is one of the most popular depictions of the prince and was often copied by other artists.

Philip IV as Huntsman, 1633–1634
Oil on canvas
189 x 124.5 cm
Madrid, Museo del Prado

The king did not pose for this hunting portrait in the open air; the painting was executed entirely in the studio.

was customary at the time, they were done entirely in the studio.

The backgrounds were all pre-painted so that the artist could concentrate his attention on the physiognomies of the royal family in the limited time available to him. These hunting portraits of the royal family were much admired. Judging by the number of copies made of it, the portrait of Baltasar Carlos was one of the most popular depictions made of that prince. A century later Francisco de Goya was sufficiently inspired by Velázquez's picture of the Spanish monarch to make his own sketch of it. After Philip IV died, Torre de la Parada became less important: the most prominent paintings were removed in the 18th century and today the buildings have fallen into ruin.

Politics in Pictures

In 1635 Velázquez painted the greatest military victory by the Spanish in the reign of Philip IV as his contribution to a series of 12 historical pictures for the Hall of the Empires in the Buen Retiro. This painting was the *Surrender of Breda*, the largest surviving work from the hand of the Spanish master.

The almost year-long siege of Breda was considered a crucial test of strength between Spain and the Netherlands, as well as a battle of wits between their two generals – Ambrogio Spinola and Justinus von Nassau – both of whom were experts in the art of fortification. The Dutch were finally forced to capitulate

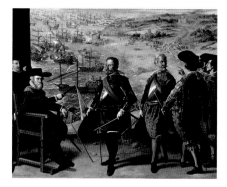

when their supplies ran out in June 1625. The lances of the Spaniards in the picture symbolize a well-ordered and upright force, while the discipline of the Dutch is seen to be already fraying. Velázquez employed a skillful compositional technique to dramatize the scene of the town keys

Francisco de Zurbarán
The Defense of Cádiz against the English, 1634 (detail)
Oil on canvas
Madrid, Museo del Prado

Besides providing a series of pictures recording the deeds of Hercules, Zurbarán contributed this single painting to the decorative program of the Hall of Empires in the Buen Retiro. It is a view of a naval battle against the English for Cádiz, a port city in the south of Spain, liberated from the Moors in 1262. With Seville it became the most important trading center for the Spanish colonies.

Fray Juan Bautista Maino
The Recapture of Bahia, 1634–1635 (detail)
Oil on canvas
Madrid, Museo del Prado

With its dominant image of a wounded man being nursed, Maino's painting focuses on the immediate aftermath of a battle. The capitulation of the enemy after the Spanish landing can be seen in the background.

being handed over to Spinola. The powerful body of the Spanish general's horse and its position in the foreground of the picture directs the gaze of the viewer towards the central scene in the middle of the picture. Here, we see the chivalrous gesture made by Spinola in not forcing von Nassau to bow while handing over the keys to the town.

The Recapture of Bahia for the Hall of the Empires is also on the theme of a Spanish victory. The artist, Fray Juan Bautista Maino, depicted people kneeling before a painting of Philip IV who is being crowned with a laurel wreath by the Duke de Olivares. Zurbarán chose yet another compositional type for his *Defence of Cádiz*; this work is reminiscent of an interior with a distant view of a naval battle, and in it the various figures have the character of individual portraits.

The Surrender of Breda, 1634–1635
Oil on canvas
307.5 x 370.5 cm
Madrid, Museo del Prado

The largest painting ever made by Velázquez, *The Surrender of Breda*, immortalizes the victory by the Spanish over the Dutch in 1625.

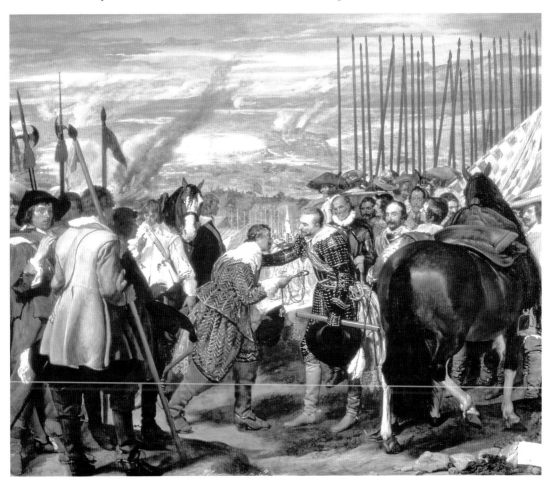

Art Imitating Life

Don Luís de Góngora y Argote, 1622
Oil on canvas
50.3 x 40.5 cm
Madrid, Museo Lazaro Galdiano

In the fine arts, Naturalism is used to refer to a method of directly imitating nature with a view to producing a copy of reality. As a movement within art history and theory, Naturalism as such took shape at the end of the 19th century. As a term it is used, for example, to characterize the pictures of Edouard Manet (pp. 68–91). An early example of Velázquez's naturalistic style is his portrait of Don Luís de Góngora y Argote. He painted this famous Spanish poet and former chaplain to Philip III on the advice of Pacheco during his first visit to Madrid in 1622. After being involved in various disputes at court, Góngora had become an embittered and isolated man, and Velázquez's depiction of him is unsparing in its honesty. In line with his naturalistic tendencies, Velázquez later painted over the laurel wreath, the symbolic attribute of the poet.

The picture of a young woman sewing was left unfinished by Velázquez. The incompleteness of the work – not necessarily an aspect of Naturalism – exerts a particular fascination on today's audience. Its still embryonic state gives the impression that it awaits further development – an impression which is, moreover, conveyed to the viewer by the way in which the picture transparently shows the stages of its construction. While the head and neckline have been painstakingly executed, there are still areas such as the materials and the rear wall which have received little attention. Even in this suspended state the picture represents a contemplative snapshot of concentration and harmony. These examples are clear evidence that, despite varying degrees of composition and completion in his work, Velázquez knew how to use naturalistic techniques to bring his work to life. Velázquez's conception of painting was imitated by many of his colleagues: Zurbarán's naturalism, for example, is expressed in the lifelike qualities of his portraits of saints. Velázquez's naturalism is marked by his extraordinarily perceptive ability to characterize individuals; at the same time, however, his sheer ability as a painter played a critical role. Velázquez was brilliantly able to play off the illusion of reality his art produced against the constraints which the act of painting itself necessarily placed upon him.

Sybil, ca. 1630
Oil on canvas
62 x 50 cm
Madrid, Museo del Prado

Opposite:
Young Woman Sewing (incomplete), 1635–1643
Oil on canvas
47 x 60 cm
Washington DC, National Gallery of Art

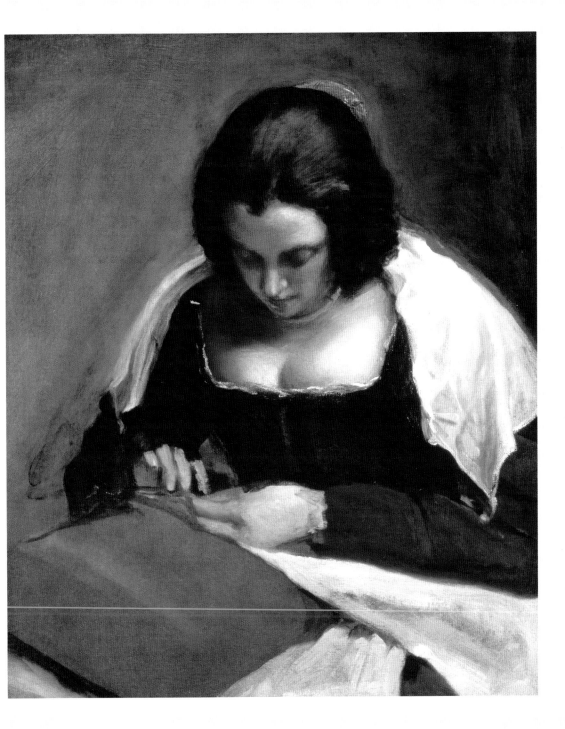

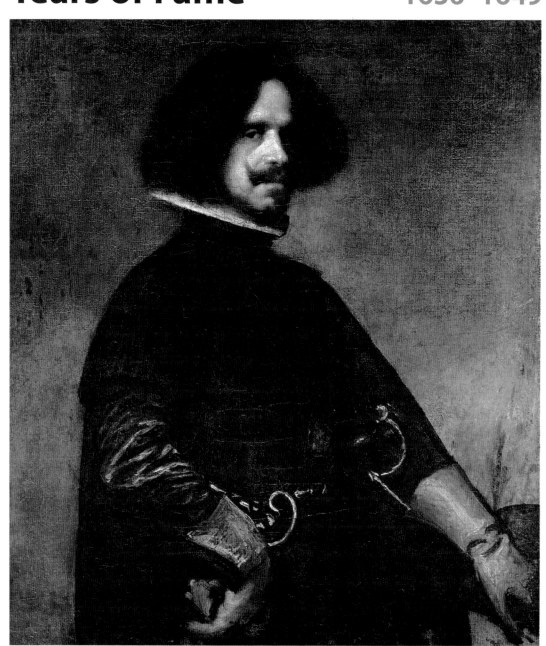

Velázquez was commissioned to produce a number of artworks for the rebuilt hunting lodge of Torre de la Parada in the Pardo game park. He was also responsible for the selection and arrangement of additional works. In 1643 the court expressed its gratitude by appointing him Painter of the Royal Chamber and Deputy to the Director of Royal Buildings.

In 1644 he accompanied the king on a journey to the war-stricken region of Aragon, where he painted Philip's portrait in the camp of the Spanish army.

In 1647 Velázquez became site manager, inspector and paymaster of an octagonal gallery in the palace at Madrid which was to house the king's masterpieces.

Diego Velázquez had reached the pinnacle of his career.

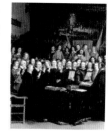

Oath of Ratification of the Treaty of Münster, 1648

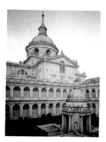

El Escorial, built 1563–1584

1637 Ferdinand III becomes Holy Roman Emperor (until 1657).

1640 Popular uprising in Portugal against Spain; John, Duke of Braganza, becomes king of Portugal (until 1656).

1643 Louis XIV, the "Sun King", becomes king of France.

1648 Thirty Years' War ends – Peace of Westphalia. Spain recognizes the United Provinces of the Netherlands.

1643 Velázquez is appointed Painter of the Royal Chamber.

1644 Paints *The Toilet of Venus*.

1645 After an interlude of almost 30 years Velázquez again takes up the theme of the Virgin Mary in *The Coronation of the Virgin*.

1648 Completes *The Fable of Arachne*, which he has worked on since 1644.

Opposite:
Self-portrait, ca. 1636 (detail)
Oil on canvas
101 x 81 cm
Florence, Galleria degli Uffizi

Right:
Philip IV Hunting Wild Boar,
ca. 1637
Oil on canvas
182 x 302 cm
London, National Gallery

Michelangelo
Buonarroti
Lorenzo de'Medici,
ca. 1520
Marble
Florence, San
Lorenzo, Cappella
Medici

Relaxed yet
melancholy –
Michelangelo's
famous marble
sculpture seen in the
Medici Chapel, church
of San Lorenzo,
Florence, is thought
to have provided the
model for Velázquez's
seated figure of Mars,
the god of war. He
knew of the
copperplate
engravings of this
sculpture and
eventually saw them
on his second journey
to Italy (1649–1651).

Mars, ca. 1639–1640
Oil on canvas
181 x 99 cm
Madrid, Museo del
Prado

Between Antiquity and Mythology

The humanist education Velázquez had received as a child had brought him into close contact with Classical history and mythology. During his first journey to Italy (1629–1631) he was able to engage directly not only with the numerous artworks of antiquity, but also with contemporary work centering on the ancient world of the gods, heroes and sagas.

Velázquez drew on these sources to paint three individual figures for the

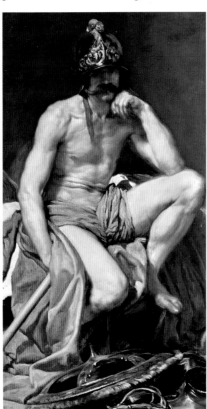

hunting lodge of Torre de la Parada (pp. 56–57). His monumental god of war, Mars, is seated on his cape clad only in a helmet and loincloth, having cast off his weapons to rest. Characterized in other paintings as youthful and full of energy, he strikes a melancholy figure. The depiction of Mars, Venus's lover, sitting with his chin supported by his hand is a traditional motif: Michelangelo's sculpture of the same motif for Lorenzo de'Medici also displays this pose. Painted for the Torre de la Parada, Velázquez's Mars is an appropriate figure for the interior of a hunting lodge – a place to recuperate after battle.

Velázquez also painted Aesop, the writer of fables, and the cynic, Menippus, specifically for the Torre de la Parada. Both these figures borrow heavily from José de Ribera's depictions of people from lowly stations in life. Indeed, without the explanatory inscriptions that accompany the paintings, the two figures could be mistaken for contemporaries of the artist. Within the lodge's decorative program, these figures were complemented by Rubens' depictions of the philosophers Democritus and Heraclitus. During his life Menippus used a merry sense of satire to poke fun at the triviality of appearances. Velázquez gave expression to the philosopher's view of the world by picturing him grinning and surrounded by objects strewn carelessly about him on the ground.

The seemingly detached and introspective figure of Aesop is depicted

Menippus,
1639–1641
Oil on canvas
178.5 x 93.5 cm
Madrid, Museo del
Prado

The ancient philosopher Menippus lived in the third century B.C. and his satires ridiculed the vanity of external appearances. Velázquez painted this picture for the interior of the Torre de la Parada; he portrayed Menippus as an old man clad in simple clothes who disregards traditional knowledge – he ignores the books lying at his feet. Menippus' smile is an echo of Peter Paul Rubens' pictures of the Classical philosophers Democritus and Heraclitus – also painted for the Torre de la Parada – shown variously laughing and weeping at the state of the world. This unusual subject needs the inscription; with Menippus' lined and blotched face, molded by exposure to wine and the Spanish sun, the viewer might otherwise assume he is one of José de Ribera's ragged and naturalistic figures placed in an anonymous interior.

with a wooden bucket, a leather cloth and dried animal hides. These are all objects taken from one of his fables in which a rich man complains about the smell coming from the property of his neighbor, a tanner, but then learns that in the interest of harmonious relations it is necessary to overcome personal objections. Velázquez invested each of these three Classical figures with a personal interpretation of their life stories, while still acknowledging the importance of literature and tradition.

José de Ribera
Aesop, 1630–1640
(detail)
Oil on canvas
Madrid, Museo del
Prado

Below:
Aesop,
ca. 1639–1641
Oil on canvas
179 x 94 cm
Madrid, Museo del
Prado

Velázquez's *Aesop* is a pendant to his picture of *Menippus*. The seemingly detached and gloomy writer of Classical fables is depicted as a man of letters and provided with symbols from one of his fables.

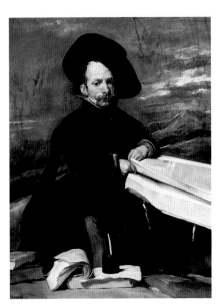

The Appeal of the Unusual

From the 16th century the fine arts began to depict normal people in comic situations, breaking a long-held tradition of picturing only dwarves as court jesters. Nevertheless, even at 17th-century European courts, dwarves were seen as human curiosities who were able to flout rigid codes of etiquette and daily routines. Physically deformed people were displayed in anatomical cabinets or portrayed in voyeuristic paintings like that of Juan Carreño de Miranda (above right). In his paintings of court dwarves Velázquez refused simply to put naked bodies on show; his interest lay in characterizing an individual free of restrictive court etiquette. He had the greatest respect

The Dwarf Diego de Acedo, 'El Primo',
ca. 1645
Oil on canvas
106 x 82.5 cm
Madrid, Museo del Prado

Held in high esteem at the court of Philip IV, the dwarf Don Diego de Acedo – called El Primo or The Cousin – held a post as administrative secretary and was admired for his erudition. Velázquez painted this portrait at the military camp of Fraga and Philip IV had the picture sent to Madrid. The open folio, the books strewn on the ground and the inkwell indicate his knowledge of literature and are attributes of his profession. The painter positioned El Primo in front of a broad landscape of hills; his portrayal of the pensive subject is sensitive and entirely free of mockery. Even El Primo's costly clothes of black damask and broad-brimmed hat – painted over in several places – emphasize the self-confidence and pride with which this courtier faces the viewer.

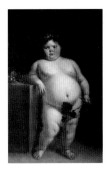

Juan Carreño de Miranda
La Monstrua Desnuda (Eugenia Martinez Vallejo Unclothed), 1680
Oil on canvas
165 x 108 cm

Madrid, Museo del Prado

Juan Carreño (1614–1680) was court painter to Charles II. Here, a deformed body displays a quite different approach from that of Velázquez. Both artists were involved in the decorations for the Hall of Mirrors (p. 86). Carreño's unsparing picture of his naked model contrasts with Velázquez's sensitivity in such matters.

for his models and there is not a trace of caricature or irony in his paintings of the dwarves. Instead, he shows them posed naturally, if unconventionally (e.g. sitting on the ground).

Don Diego de Acedo, called "El Primo", a particularly gifted court official, held a post as secretary from 1635 until his death in 1660. Velázquez painted his portrait at the military camp of Fraga, while journeying with the king to the battlefront. El Primo is portrayed here with dignified earnestness, the folio and other objects indicating his administrative profession.

The court dwarf Francisco Lezcano was in the service of Prince Baltasar Carlos from 1634. Velázquez painted him in front of a rocky landscape holding a deck of cards – one of the pleasurable court pursuits.

Don Sebastian de Morra was another dwarf in official service; he

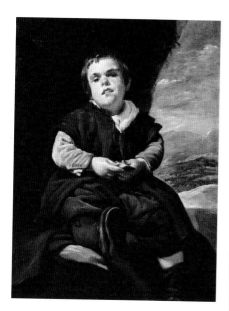

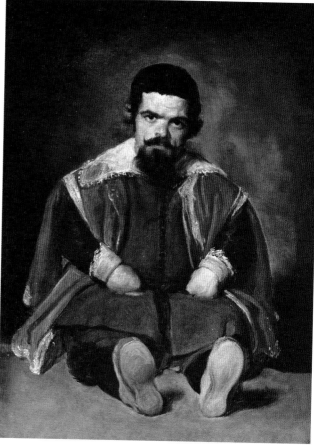

was initially a member of Cardinal Infante Don Fernando's entourage and, from 1643, he served Prince Baltasar Carlos. Velázquez's painting shows him in an unusual pose seated on the ground with his legs stretched out in front of him and the soles of his feet facing the viewer.

All three pictures were painted for the hunting lodge of Torre de la Parada, where they were hung high over the doorways; this explains the seemingly heavy proportions in the lower part of the composition. The intense play of light and shadow, the variations in the application of the brush, and the sensitive characterization of the three individuals mean that these works – along with the official state portraits – occupy a special place in Velázquez's oeuvre.

Top left:
The Dwarf Francisco Lezcano (El Niño de Vallecas), 1643–1645
Oil on canvas
107.5 x 83.5 cm
Madrid, Museo del Prado

The dwarf Francisco Lezcano is pictured clad in a green cloak, absent-mindedly shuffling a deck of cards.

Top right:
Don Sebastián de Morra, ca. 1645
Oil on canvas
106.5 x 81.5 cm
Madrid, Museo del Prado

Don Sebastián de Morra was initially in the service of the Cardinal Infante Don Fernando. In 1643 he arrived in Madrid and was given a position with Prince Baltasar

Carlos. Here he faces the viewer and is positioned well into the foreground. De Morra was considered an argumentative man; Velázquez highlights this trait in his energetic pose, clenched fists and the critical gaze with which he seems to regard the viewer.

The Color Black in the Fine Arts and in the Work of Velázquez

The color black, and the way it has been used, have gone through a number of stages in fine art history. Painting itself depends upon the modeling and combination of surfaces of color to achieve a specific effect. Painters soon discovered that by varying the darkness of the background, and even by rendering it completely black, they could make foreground objects stand out. Using this technique still-life painter Jan de Heem (1606–1684) made the bright bunches of flowers bloom against an intensely dark background. The lack of a relationship between the object and its surrounding space made his still-lifes appear as if they were superimposed, giving them a more compact form. For de Heem, black was merely a background surface onto which other objects could be projected and highlighted.

The 20th century saw the fine arts begin to move away from the straightforward representation of objects to the rendering of abstract forms in pure color. A crucial step in the evolution towards this idea of autonomous color was taken by the Impressionists – a group that included Edouard Manet – at the end of the 19th century. For the Impressionists, pictorial colors did not have to reflect true colors; instead, they were held to provide a momentary impression of an object. Liberating black from any kind of representational function opened up new, innovative possibilities – hence Malevitch's *Black Cross*. From now on, art would exist only for its own sake.

Jan de Heem
Still-life of Flowers,
ca. 1680 (detail)
Oil on canvas
325 x 204 cm
Cambridge, Fitzwilliam
Museum, University of
Cambridge

Kasimir Malevitch
Black Cross, 1920
Oil on canvas
106 x 106 cm
St Petersburg, Russian State
Museum

Edouard Manet
Emile Zola, 1868
Oil on canvas
146 x 114 cm
Paris, Musée d'Orsay

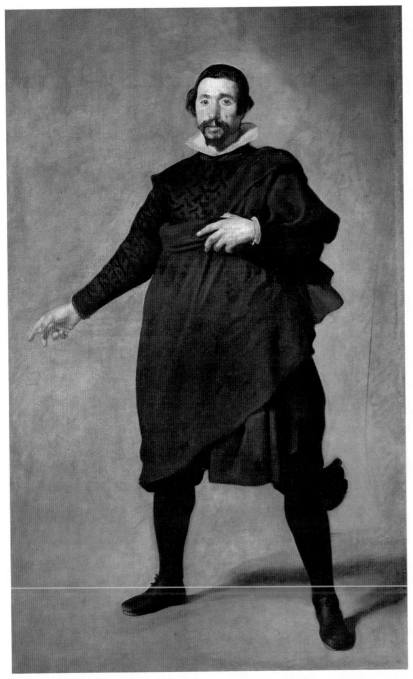

In Velázquez's paintings black not only had a descriptive function, it also played an active role in determining the structure of objects and acted as an autonomous element within the picture. Velázquez was a master of the nuances produced by light on black pigments, a technique that in some respects makes him comparable to Rembrandt (p. 90). In his portrait of Pablo de Valladolid from the mid-1630s, Velázquez depicted his model clad entirely in black against an undefined background. This emphasis on black lends the figure its own sense of space. Velázquez had a whole register of subtly graded black tones with which he was able to produce highly differentiated structures on the surface of his paintings. These structures in turn served to bring out the plasticity of the figures. Velázquez was not a color theorist but his own innovative treatment of color made him an experimental practitioner. His immediate successor in the application of this technique was Francisco de Goya (1746–1828).

The Buffoon Pablo de Valladolid, 1636–1637
Oil on canvas
213.5 x 125 cm
Madrid, Museo del Prado

Religious and Secular Themes

The portraits of the royal family, often of huge dimensions, left Velázquez with little time for religious and historical themes. An exception is his *The Coronation of the Virgin by the Trinity*. According to Velázquez's biographer, Palomino, it was originally intended as a devotional picture for Isabella of Bourbon and was to be hung in the oratory of the queen's apartment of the royal

palace. The queen died in 1644; Velázquez's last altarpiece must have been made immediately before this event. His composition is modeled on an engraving by Paulus Pontius after Rubens. God and Christ place a crown of delicate rose petals on the head of the Virgin, who is borne up by angels. The figures appear to be seated on invisible chairs. In contrast to his earlier religious pictures, Velázquez's figures here are strongly idealized.

The picture of Venus looking at herself in a mirror, on the other hand, is an example of one of Velázquez's secular works. It is the only nude he ever painted. Titian in his painting of *The Toilet of Venus* focused on the goddess tending to her appearance, thus legitimizing the display of nudity. Velázquez, however, concentrated completely on the nude at the expense of any activity. His Venus is positioned closer to the foreground with the viewer's gaze directed at her back. The various layers of vision in the painting are effectively articulated: the viewer looks at Venus, while she gazes into the mirror and, therefore, indirectly back at the viewer. The amorino – his wings looking like a flimsy stage prop – holds a mirror up to the goddess and smiles back at her. Goya later took up the theme of the profane nude but positioned his model so that she faced the viewer directly.

Titian
The Toilet of Venus,
1555
Oil on canvas
124.5 x 105.5 cm
Private collection

Titian often painted female nudes but he always looked for a literary pretext such as this scene of the

Classical goddess Venus at her toilet. Amor, the god of love, holds a mirror up to Venus who – as was usual in such pictures – faces the viewer. Velázquez was familiar with one of the many versions of this picture from the royal collection. In his only surviving nude, the Spanish artist developed Titian's interplay of erotic revelation and modesty into a naturalistic portrayal.

Top:
Francisco de Goya
The Naked Maja,
1797. Oil on canvas
97 x 190 cm
Madrid, Museo del Prado

In this work by Goya, developed from Velázquez's composition, the model's gaze fixes the viewers – changing the picture's very essence.

Bottom:
The Toilet of Venus,
ca. 1644
Oil on canvas
122.5 x 177 cm
London, National Gallery

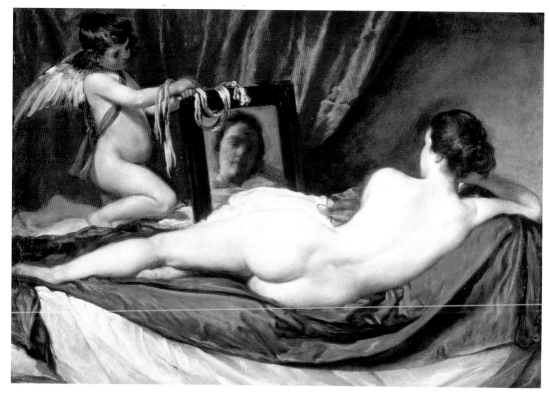

The Fable of Arachne

The theme of competitions recurs constantly in the arts ,and literature, and it is used to achieve a particularly vivid description of character. Morality and practical ability are often played off against each other, the eventual defeat of the impudent challenger serving as a valuable moral to the story.

An example of this kind of tale is *The Fable of Arachne* as related in the *Metamorphoses* by Ovid. Velázquez made the story the subject of one of his paintings while he was at the height of his fame. His picture is a detailed and multi-layered work which gives the impression that Velázquez himself wished

to compete with the colorful narrative skills of the ancient Roman author. *Arachne* was painted some time between 1644 and 1648, probably as a commission for Pedro des Arce, a member of the court in whose collection it was recorded in 1664. Arachne, the daughter of a Lydian dyer, was famed

for her weaving skills. In her arrogance she challenged Pallas Athene, the formidable patron goddess of the arts, to a

The Fable of Arachne (The Spinners), ca. 1644–1648
Oil on canvas
220 x 289 cm
Madrid, Museo del Prado

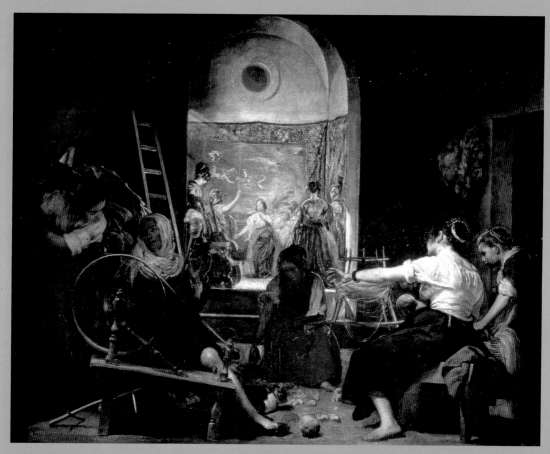

weaving competition.
In four of her six scenes,
Athene showed mortals
challenging the gods, while
Arachne chose scenes of
humans leading the gods
astray. The competition was
won by Athene who,
though full of praise for the
ability of her challenger,
was so outraged at the
mortal girl's impudence
that she transformed
Arachne into a spider.
Contrary to accepted
artistic conventions,
Velázquez did not paint the
two weavers directly
competing against each
other, but instead
combined different
elements of the fable

Michelangelo Buonarroti
Ignudi, 1508–1512
(detail of ceiling fresco)
Rome, Vatican, Sistine
Chapel

in a simultaneous
representation. In the
foreground the weavers are
seen working in a room
adjoined at the rear by
another, flooded with light.
There, the goddess is seen
raising her arm and
announcing her opponent's
punishment before three
witnesses. Both the women
seated in the foreground
introduce the viewer to the
story and direct his gaze
into the depths of the

**The Fable of Arachne (The
Spinners)**, ca. 1644–1648
(detail)
Oil on canvas
220 x 293 cm
Madrid, Museo del Prado

picture; they are modeled
after Michelangelo's *Ignudi*
in the Sistine Chapel, which
Velázquez studied while in
Italy between 1629–1631.
The wall hanging depicting
the abduction of Europa on
the rear wall was inspired
by a copy of a Titian
painting made by Rubens.
Large areas of the painting
show the familiar style of
the artist: the mythological
story is shown as a genre
scene with still-life

components such as those
Velázquez might have
chosen for his *bodegones*.
Velázquez was probably
fascinated by an
interpretation of the fable
suggested by Viana, Ovid's
translator, who saw the
story as a parable on the
frustration of the artist
denied recognition of his
work. At the same time the
picture may well be a
general warning to the
artist not to try to measure
himself against the power
of God.

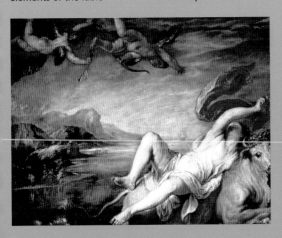

Left:
**The Fable of Arachne
(The Spinners)**,
ca. 1644–1648 (detail)
Oil on canvas
220 x 293 cm
Madrid, Museo del Prado

Far left:
Peter Paul Rubens
**Copy after Titian's Rape
of Europa**, 1628–1629
(detail)
Oil on canvas
181 x 200 cm
Madrid, Museo del Prado

The Perfection of Art 1649–1660

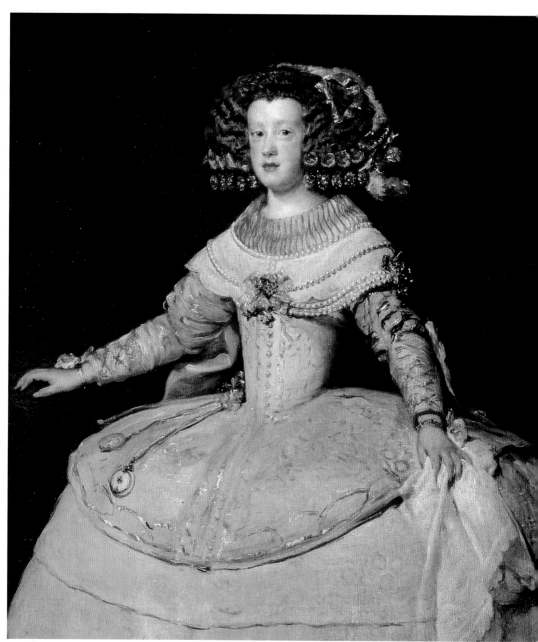

In 1649 Velázquez set off on his second journey to Italy. He visited Genoa, Venice, Parma, Modena and Rome, where he was appointed a member of the Academia di San Luca after exhibiting the portrait of his assistant, Juan de Pareja. His portraits of church dignitaries, especially that of Pope Innocent X, met with great success. In addition to his paintings and studies, he purchased Classical sculptures and Renaissance pictures for the collection of Philip IV.

In 1651 Velázquez returned to Spain, where he painted the portraits of the Infanta Maria Theresa and Philip's second wife, Mariana, in Madrid. All these works were, however, surpassed by the most famous of Velázquez's paintings and one of the most outstanding pictures of all time: his self-portrait with the royal family known as *Las Meninas*.

While travelling as a member of the king's entourage, Velázquez fell seriously ill; he died on 6 August 1660, soon after returning to Madrid.

Opposite:
The Infanta Maria Theresa,
1652–1653 (detail)
Oil on canvas
127 x 98.5 cm
Vienna, Kunsthistorisches
Museum

Right:
Dwarf with a Dog, ca. 1675
Oil on canvas
100.6 x 81 cm
Museo del Prado

Thomas Hobbes, ca. 1669

Las Meninas, 1656 (detail of the artist)

1649 England becomes a republic after the execution of King Charles I.

1650 Rule of the States General in the Netherlands after the death of William II.

1651 Thomas Hobbes publishes *Leviathan*, the first modern theory of government.

1652 Naval war between England and the Netherlands reinforces England's domination of the seas.

1659 Peace of the Pyrenees forms the basis for conflict between Spain and France; the latter now becomes the strongest power in Europe.

1660 Jan Vermeer paints *The Letter*.

1646–1651 Second journey to Italy. Velázquez becomes a member of the Accademia di San Luca in Rome and paints the portrait of Pope Innocent X while resident in the city.

1652 Appointment to the position of Palace Chamberlain.

1655 Velázquez moves into the Casa del Tesoro, a building in the east of the royal palace.

1656 Paints the famous work known today as *Las Meninas*.

1659 Velázquez becomes a member of the Order of St James.

1660 Velázquez accompanies Philip IV on a journey to sign a peace treaty with France. He returns to Madrid gravely ill and dies there on 6 August. His wife Juana dies a week later and is laid to rest beside her husband in the church of San Juan.

The Italian Portraits

Velázquez was to have sailed to Italy in the entourage of the Duke of Nájera at the end of 1648, but the journey was postponed until the beginning of 1649. After arriving in Italy he spent some time in the north of the country before later traveling on to Rome.

As he had during his first stay in Italy (1629–1631), Velázquez viewed a number of art collections, and was required to purchase interesting work for Philip IV. One of the artist's most urgent tasks was to paint portraits.

While still in Spain he had drawn a study for a portrait of Cardinal Borgia, but while in Italy he received a much more important commission from the Roman prelate and later papal nuncio Camillo Massimi, who was the Pope's chamberlain.

Study for a portrait of Cardinal Borgia,
1643–1645
Drawing
18.8 x 11.6 cm
Madrid, Real Accademia de Bellas Artes de San Fernando

This study, made in Spain, is one of Velázquez's few surviving drawings.

Top right:
Monsignor Camillo Massimi, 1650
Oil on canvas
73.6 x 58.5 cm
London, The National Trust

Monsignor Massimi was in influential prelate at the papal court. As such he enjoyed a rather better reputation as an arts connoisseur than he did as church official. Apart from his own portrait, he purchased further works from the artist, with whom he was also friendly. In Rome, Velázquez's main duty was portraiture; he also bought artworks for the royal collection.

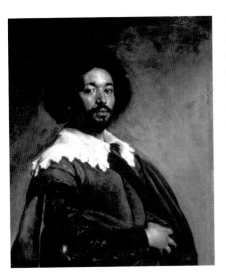

Massimi was a learned man, active as both patron and collector, who became a close friend of Velázquez. His portrait shows Massimi wearing the blue robes of his office which cast a delicate bluish shadow onto his white collar. The depiction of the sitter in a chair with armrests is taken from the motif of a throne, and therefore corresponds to the conventions of representation appropriate to a member of the papal court.

In the expectation that he might be invited to portray the pope himself, Velázquez painted a portrait of his assistant, Juan de Pareja, who had accompanied him to Italy. Pareja had been born on an unknown date in Antequera and was the court painter's slave until 1654. While still in Rome Velázquez signed documents making Pareja a free man, who then went on to work as a painter himself until his death in

1670. Velázquez painted Pareja's portrait in order to demonstrate his artistic ability to church officials, but also to show his Roman colleagues what he was capable of. Exhibited in the Pantheon, the picture was greeted with a storm of enthusiasm and the painter was honored with a membership to the respected Accademia di San Luca and the religious association of artists, the Congregazione dei Virtuosi al Pantheon. Diego Velázquez left Rome in 1650 at the urging of Philip IV; he then made a detour through Modena and Venice, and it was not until 1651 that he once again reached Madrid after an absence of two and a half years.

Left:
Juan de Pareja,
1649–1650
Oil on canvas
81.3 x 69.9 cm
New York,
Metropolitan
Museum of Art

Velázquez depicted his 'slave' in a proud pose with the sitter directing a self-confident gaze at the viewer. By placing his subject's arm across his chest Velázquez gives Pareja an air of inner calm and resourcefulness.

Below:
Dome of St Peter's in Rome, photo

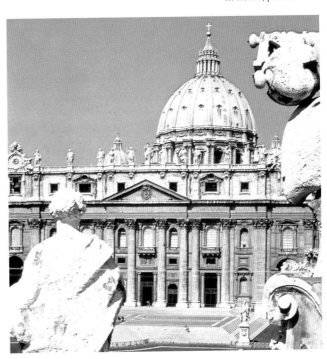

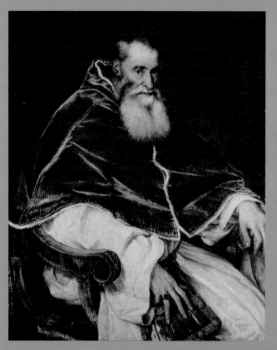

The History of a Motif

While in Rome, Velázquez had demonstrated his artistic skill with his portrait of Juan de Pareja, and in spring 1650 his ambitions were finally rewarded when he received a commission to paint the portrait of Pope Innocent X.
This pope had been born Giovanni Battista Pamphili in 1574 and was elected to the Holy See in 1644. Velázquez chose to represent this powerful man as a three-quarter length figure, a format which had been established by Titian's picture of Paul III. El Greco (1541–1614), a native of Crete who worked largely in Spain, also used Titian's model but developed it by placing his full-length figure in an interior. Velázquez avoided El Greco's narrative form concentrating instead – like Titian – on presenting the pope directly to the viewer. The numerous copies made of this work and its effect on later papal portraits, show that Velázquez had achieved an innovative formula which spoke to the age. His use of color as a means of characterization was central to this effect; the red which dominates the picture was given a range of nuances from the impulsive dark tones of the curtain, to the upholstery of the chair and through to the pope's cape. In this way, he was able to set up a series of dynamic contrasts which focus on the piercing gaze of the pope at the center of the picture as a manifestation of Innocent X's claims to secular authority.
The tight framing of the picture reduces the

Above right:
Francis Bacon
Study after Velazquez's Portrait of Pope Innocent X, 1953
Oil on canvas
152 x 118 cm
New York, William Burden Collection

Above left:
Titian
Pope Paul III, 1543
Oil on canvas
114 x 89 cm
Naples, Museo Nazionale di Capodimonte

El Greco
Portrait of Cardinal Niño de Guevara, 1596–1601
Oil on canvas
104 x 130 cm
New York, Metropolitan Museum

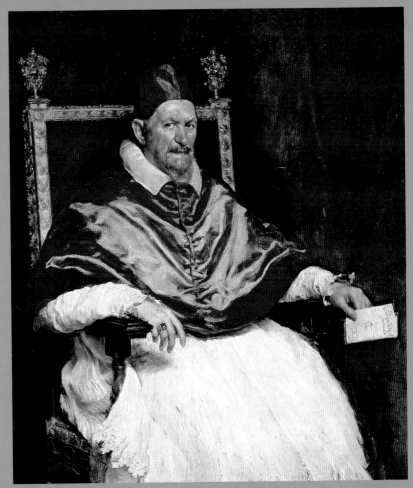

distance between the viewer and sitter so that this powerful ecclesiastical figure appears tangible and alive.

Through the techniques of color and composition, Velázquez achieved a characterization of the sitter that penetrated external appearances, exposing the inner depths of the human soul. That this charged mood behind the surface of his figurative subject matter is still apparent after several centuries is an indication of the extraordinary quality of this painting. Francis Bacon, one of the outstanding painters of the 20th century, perceived a kind of violence in the painting and his interpretation of the work expresses this in the scream of an immobilized and imprisoned pope.

Pope Innocent X was very satisfied with Velázquez's work and presented the painter with a gold medallion. In recognition of the artist's "extraordinary achievements", Innocent also supported Velázquez in his efforts to be accepted into the Order of St James, a religious order of knights.

Velázquez returned to Spain with one of the 20 known copies of this work. In Madrid, the papal nuncio praised its accuracy in recording its subject and even a century later the English painter Sir Joshua Reynolds (1723–1792) called it "one of the world's first portraits."

Innocente X, 1650
Oil on canvas
140 x 120 cm
Rome, Galleria Doria Pamphili

The Royal Collection

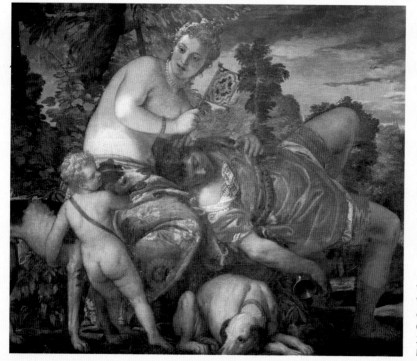

Above:
Albrecht Dürer
Self-portrait, 1498
Wood
52 x 41 cm
Madrid, Museo del Prado

The importance of Velázquez's work for Philip IV's superb and extensive art collection was twofold, and consisted both of the works he contributed himself and those he purchased for the king during his visits to Italy in 1629 and 1649. The royal collection had been established by Philip II (1556–1598); although he was initially only a collector, he soon appointed his own court painters. His

grandson, Philip IV, largely kept himself apart from affairs of state, transferring these duties instead to his prime minister, the Duke de Olivares. This allowed him to concentrate entirely on his abiding passion – the expansion of his own collection through the purchase of art objects and works of famous painters. Philip IV had a number of buildings at his disposal to house his acquisitions – El Escorial, Buen Retiro and

the hunting lodge Torre de la Parada – all of which had been enlarged to serve as visible symbols of state power. The decline of Spain as a force to be reckoned with in Europe became ever more obvious with the passage of time; ever greater displays of state magnificence became necessary to conceal this loss and preserve the status of the crown. In order to bolster the Habsburgs' sense of self-worth, lavish backdrops were built, such as the Hall of the Empires in the Buen Retiro palace. The paintings exhibited in these rooms were intended to demonstrate the state's power and fame. And of course, the more important the artist was, the more useful he became for such representational purposes. The high standards which Philip IV set for his collection could not be met by his court painter alone, and this meant that the monarch had to look beyond Spain for suitable work to buy. In the mid-17th century, Italy still enjoyed a reputation as the

Veronese
Venus and Adonis,
ca. 1580
Oil on canvas
212 x 190 cm
Madrid, Museo del Prado

Titian
Virgin and Child with Saint Anthony and Saint Roch, 1505 (detail)
Oil on canvas
90 x 70 cm
Madrid, Museo del Prado

center of the European art world, and for this reason Velázquez was officially commissioned to buy art for the king on his many journeys there.
Although this was widely known in official circles in Spain, it was not greeted with unanimous approval because of the country's poor economic situation. In spite of numerous objections, however, Philip IV entrusted Velázquez not only with the purchase of paintings, but also with the expensive and time-consuming task of making casts of antique statues. This required him first to make a rigorous selection of appropriate works and then to obtain the approval of the owners – something that was not always easy to achieve. Permission to visit

the pope's collection of antiquities in the Belvedere, the most comprehensive anywhere, required extensive negotiations. Velázquez followed his own preferences in purchasing paintings. As he had the greatest respect for the Venetian school, he made efforts to buy works by Tintoretto (1518–1594) and Paolo Veronese (1528–1588) including a depiction of Venus and Adonis, a pair of star-crossed lovers from ancient mythology.
The collection was expanded by other means as well. When artworks belonging to Charles I of England were auctioned off in 1649 after his execution, several pieces were bought by the Spanish king. Amongst these were Andrea del Sarto's *Virgin with Child* which was bought by Alonso de

Andrea del Sarto
Virgin with child,
1515–1520
Oil on wood, 177 x 135 cm
Madrid, Museo del Prado

Cárdenas on Philip IV's behalf. This picture, in a high vertical format, shows the Virgin with Child, flanked by an angel and a saint in a broad, hilly landscape. Titian's *Virgin and Child with Saint Anthony and Saint Roch*, painted in 1505, also found its way into the royal collection. For this work the Venetian painter had chosen a broad format in which he took the unusual step of placing the saints at some distance from the Virgin and Child. Flemish paintings – especially those of the great Baroque artist, Rubens – were also popular. Purchases of German pictures were less

common, though an exceptional work of German origin – Albrecht Dürer's *Self-portrait* of 1498 – was also included in Philip IV's collection. The royal collection later formed the basis for the holdings of the world famous Prado Museum in Madrid, in which Velázquez's works occupy an especially important position (p. 87).

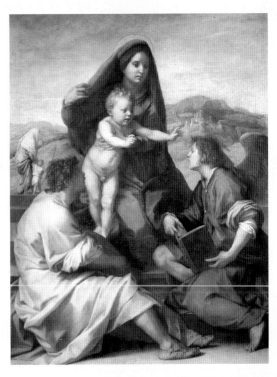

Prince Philip Prosper, 1659
Oil on canvas
128.5 x 99.5 cm
Vienna,
Kunsthistorisches Museum

Prince Baltasar Carlos's death in 1642 left Prince Philip Prosper as royal successor. His portrait and that of his sister were sent to the Imperial court in Vienna, for the other branch of the Habsburg dynasty to see the future monarch.

The Royal Children – the Infantes

The hopes of the Spanish crown rested with the royal children – with Philip Prosper as the official heir to the throne, and with the Infanta Margarita, who was engaged to her cousin Leopold, the German emperor, shortly after she was born.

In 1649 Philip IV had married his 15-year-old niece Mariana, in the hope of producing a successor. Philip's son from his first marriage, Prince Baltasar Carlos, had died in 1642 two years before his mother, Isabella of Bourbon. A daughter from this first marriage, the Infanta Maria Theresia, married the "Sun King", Louis XIV of France, in 1660.

In 1651 Queen Mariana gave birth to the Infanta Margarita, who would marry the German emperor Leopold I in 1666 but then die young in 1673. It was not until six years after the birth of Margarita that Prince Philip Prosper, the long-awaited heir to the throne, was born. This son, too, was condemned to a short life: he died in 1661 at the age of four, an event that Velázquez himself did not live to witness.

In 1653 Velázquez painted the Infanta Margarita for the first time. The two-year-old girl stands in the conventional pose of an important personage on a flat podium, her body turned slightly to the side and her gaze directed out of the picture. At her side the painter placed a vase of flowers from which one bloom

Right:
The Infanta Margarita, 1653
Oil on canvas
128.5 x 100 cm
Vienna,
Kunsthistorisches Museum

The Infanta Margarita was the second child from the king's marriage to his niece Mariana, his second wife. In 1666 the Infanta married the German emperor Leopold I in Vienna. Velázquez portrayed her as a two-year-old girl in a pink and silver dress with butterfly bows. She stands on a flat podium and rests against a table covered in a silver-blue cloth and decorated with a vase of flowers. In her

left hand she holds a fan. The delicate tones of the dress are repeated in the Infanta's face and blonde hair – as well as in the flowers – which create a strong contrast with the dark background.

has fallen; this still-life serves to lighten the mood of the work.

Velázquez painted several portraits of the Infanta; the last of these, begun in 1660, was finished by Juan Bautista Martínez del Mazo, the artist's son-in-law.

The portrait of Philip Prosper shows the two-year-old in a pink garment. In contrast to the painting of Prince Baltasar Carlos (p. 47) he bears no insignia of power; instead, there are amulets which are represented in order to protect him from the evil eye and – in memory of Philip's first son – protect him from an early death. The small dog resting in the heavy armchair to his side helps to reduce the dignified austerity of the picture and lends the painting a mood of gentle animation. This composition type – a standing child with a small dog – was probably familiar to Velázquez from Titian's portrait of two-year-old Clarissa Strozzi from 1542, one of the very first true portraits of a child in European art. Titian was famed for painting realistic portraits of children which captured their characters with great empathy but without merely depicting them as miniature adults. Velázquez showed a similar sense of empathy in his children's portraits; while acknowledging the exacting demands of pictorial conventions which had to be applied to any painting of the heir to the throne, the artist achieved an almost playful portrait of the young prince.

Titian
Clarissa Strozzi,
1542 (detail)
Oil on canvas
115 x 98 cm
Berlin, Staatliche Museen zu Berlin, Preußischer Kulturbesitz, Gemäldegalerie

The Infanta Margarita, ca. 1656
Oil on canvas
128 x 100 cm
Madrid, Museo del Prado

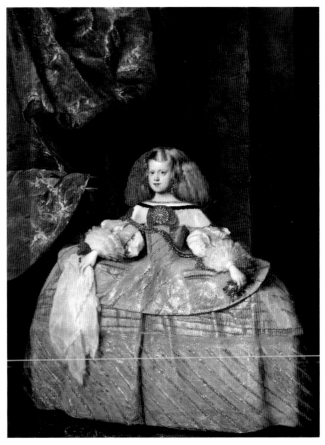

Las Meninas – the Theology of Painting

Jan van Eyck
The Arnolfini Marriage,
1434
Oil on wood
82 x 60 cm
London, National Gallery

In 1656 Velázquez completed a monumental group portrait which was first popularly known as *The Family of Philip IV*. It was not until the 19th century that the painting was given its present name of *Las Meniñas* (The Maids of Honor).

The setting is Velázquez's studio in the royal palace in 1655. At the center of the picture is the five-year-old Infanta Margarita, the daughter of Philip IV and Mariana of Austria, who is attended by two maids of honor. The artist himself can be seen to her left.

Velázquez is pictured momentarily pausing in front of his easel with his brush in his hand. The cross of the Order of St James can be seen on his doublet; this was added after his death on the orders of the king. On the rear wall, Philip IV and Mariana can be seen reflected in the mirror. The idea of depicting figures through reflections in a mirror was familiar to Velázquez from Jan van Eyck's so-called *The Arnolfini Marriage*, which in the artist's day was located in Madrid. The left hand side of the picture is

completed by two court dwarves and a dog. Through an open door in the rear wall we can see Don José Nieto Velázquez, the queen's major-domo. Seldom has a painting provoked such a range of interpretations. The actual theme of the work has yet to be satisfactorily explained: it may depict Velázquez as court painter at work on a portrait of the royal couple, who would be situated in the same location as the presumed viewer. It may also be a portrait sitting of the Infanta Margarita being interrupted by her parents. The brilliance of the composition lies in its conception of the studio as a stage on which each figure is both actor and spectator. The complexity of the work can therefore be explained by the multiplicity of visual levels: the painter may be gazing at the viewer of the picture or at his sitters, the royal couple.

The viewer of the painting can never be sure what role is assigned to him/her in

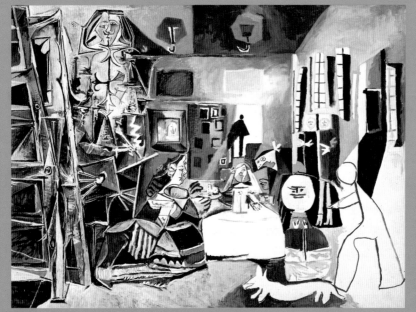

Pablo Picasso
Las Meninas (after Velázquez), 1957
Oil on canvas
194 x 260 cm
Barcelona, Museu Picasso

> *Velázquez transformed his portraits, as if by magic, into some of the most fascinating pieces of painting the world has ever seen.*
>
> Ernst H. Gombrich, *The Story of Art*

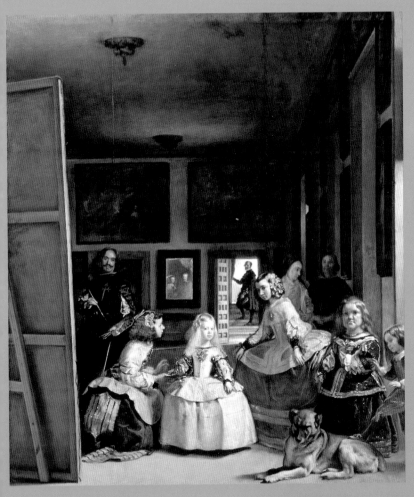

Las Meninas (The Maids of Honor), 1656
Oil on canvas
318 x 276 cm
Madrid, Museo del Prado

the set-piece that the picture represents: is he/she looking at a scene independent of his/her presence, or is he him/herself being portrayed by the painter? The various illusory layers within the picture were brilliantly constructed by Velázquez. The artist was a man well versed in philosophy and art theory who immersed himself in scholarly treatises on painting. His large library in the royal palace contained books on perspective, geometry and optics, including *Four Books on Human Proportion* by the German Renaissance painter Albrecht Dürer (1471–1528).

This picture was already famous during the painter's lifetime. Luca Giordano, later a court painter himself, was so impressed that he called *Las Meninas* the "theology of painting." The Spanish painter Pablo Picasso also investigated the relationship between viewer, subject and artist in around 40 of his paintings, and in 1957 he painted his own interpretation of what is probably Velázquez's most famous work.

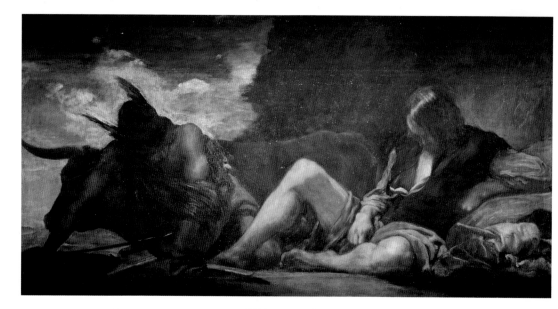

Fame and Late Works

After his second journey to Italy in 1651, Velázquez received a number of honors, including his appointment as Palace Chamberlain in 1652. It was in this capacity that in 1655 he moved into the Casa del Tesoro, a building to the east of the royal palace. His official duties, however, barely left him with enough time to paint.

One of the most ambitious goals Velázquez had set himself was to be accepted into the Order of St James, one of the most prestigious orders of religious knights. The success of Innocent X's portrait (pp. 78–79) secured him the support of the pope in this undertaking. In 1658 Philip IV commissioned research designed

Philip IV, 1652–1655
Oil on canvas
69 x 56 cm
Madrid, Museo del Prado

This bust is Velázquez's last portrait of the king but it does not so much as hint at age or infirmity. In the course of his career the painter was often asked to depict the monarch, but never in an unflattering light.

Above:
Mercury and Argus, 1659
Oil on wood
128 x 250 cm
Madrid, Museo del Prado

Velázquez was responsible for planning the renovation of the Hall of Mirrors in the royal palace, finally contributing his own painting with this picture of Mercury and Argus. The broad format was suitable for its position in the room over a window. The monumentality of the figures creates a deep spatial impression, and the coloration in the broad brushstrokes serves to obscure the features of their faces.

Below:
Queen Mariana, 1652–1653
Oil on canvas
234 x 131.5 cm
Madrid, Museo del Prado

The 19-year-old queen married her uncle, Philip IV, in 1649. Here, her elaborate dress overpowers her.

to prove that Velázquez was of noble descent and that the artist had never been involved in work unbecoming to his station.

In November 1659 the king inducted his protégé into the Order of St James, the crowning moment of the painter's attempts to achieve social respectability.

Velázquez always knew how to combine great artistic ability with skillful diplomacy towards those in power, or those who might be of some use to him. One of his last artistic tasks was the architectural supervision of some minor renovation work on the royal palaces. In addition he continued to work on portraits of the royal family, which had always been his main responsibility.

The half-length portrait of the aging Philip IV dressed in black and the portrait of Queen Mariana date from the very last years of the artist's creative life.

Velázquez prepared the artistic decorations for the ceremony marking a peace treaty between Spain and France, and he was present at the signing ceremony on the Bidasoa river at the border between the two countries. On 26 June 1660 he returned to Madrid gravely ill. He never recovered from his exertions, however, and despite the excellent care of the king's own physicians he died on 6 August 1660. In the presence of royal dignitaries and much of the court nobility, Diego Velázquez was buried in the church of San Juan wrapped in the cloak of the Order of St James. His wife, Juana, survived him by just a week and was later buried at his side.

The Museo del Prado in Madrid, photo

The Prado is one of the world's most famous museums and houses a superb collection of Old Masters from the Flemish, Dutch, Italian and Spanish schools. The basis of the collection is formed by work formerly in royal ownership, to which was added material from the secularized monasteries in 1872. The museum is named after the Prado de S. Jerónimo park in which building work began in 1785. In 1819 the royal museum for painting and sculpture was opened. Nationalized after the military coup of 1868, it was transformed into a state museum. The Prado has the world's largest collection of work by Diego Velázquez. Recent conservation work on his paintings as well as the museum's new hanging policy have been designed to give the visitor the most comprehensive look at the art of this prominent 17th-century artist.

What Makes a Velázquez a Velázquez?

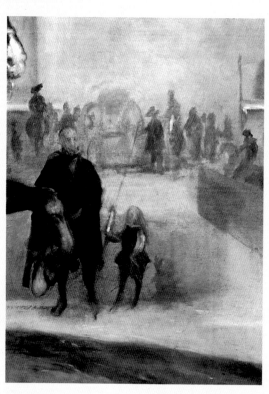

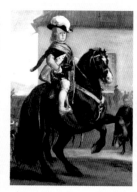

Technique

In Velázquez's earliest paintings the realistic recreations of the slightest detail were paramount - as can be seen in the tiny drops of water on the jug in *The Water Seller* (p. 23).
In Madrid he began to paint by modeling small sections of various sizes within the overall composition. By using thin layers of pigment applied with short, broad brushstrokes he developed a type of transparent coloration that lent the faces in his portraits a particularly lifelike quality – one of the most outstanding qualities of his paintings. Though his palette was initially dark – as in the *The Three Musicians* (p. 15) – it was later modified by the use of a silver-grey ground as can be seen in his picture *The Fable of Arachne* (pp. 72–73).

Physiognomy

Velázquez's particular interest lay in portraying his sitters as individuals. Rather than simply create a mirror image of his models he always attempted to portray their inner character.
His *bodegones* (pp. 18–19) had already proved his talent for depicting the essential humanity and lifelike qualities of his figures. Velázquez modeled the human form using bright light in order to capture the essentials of people's faces as in the portrait *Philip IV in Armor* (p. 28). A number of thin layers of pigment applied on top of each other rendered the individual brushstrokes invisible and created a soft, painterly effect that allowed the flesh tones to appear more true to life.

Chiaroscuro

The Italian painter Caravaggio (1571–1610) used harsh light and brilliant reflections to create compositions marked by stark contrasts. Velázquez initially oriented his art after Caravaggio's to achieve a plasticity and expressiveness through dark, strictly defined shadows and a palette of somber, earthy tones; these features can be seen in his *Three Men at Table* (p. 14). Later, the bright side-lighting would be replaced by a more diffuse use of light and less opaque shadows. In his more mature work contrast gave way to surfaces modeled in bright light, and the use of opposites was transformed in favor of a more unified effect, as seen in *Las Meninas*.

Composition

In his early work Velázquez was concerned with representing individual, isolated objects as accurately as possible, as in *Kitchen Scene with Christ in the House of Martha and Mary* (p. 18). After his move to Madrid he combined elements within the picture more adeptly and became a master of composition, as his painting *Prince Baltasar Carlos in the Riding School* shows. One of the ways he was able to create a convincing unity in his pictures was by connecting lines of sight with each other, often by placing spectators within the picture. With these seemingly spontaneous motifs that conveyed the immediacy of the moment, Velázquez anticipated the photographic techniques. This was one of the reasons why his work attracted the attention of the 19th-century Impressionists, who were interested in investigating the effects of the new technology (photography) on painting.

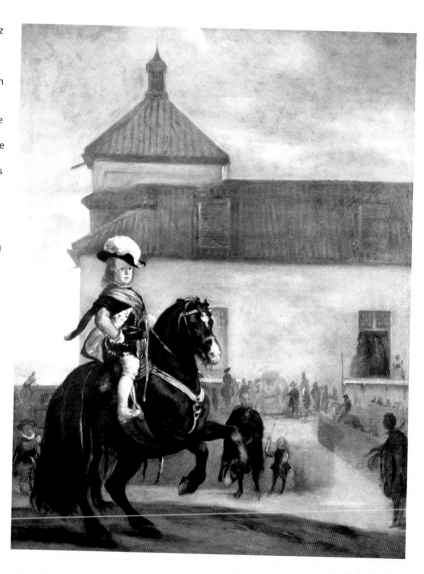

Right and opposite:
Prince Baltasar Carlos in the Riding School, ca. 1636
Oil on canvas
144 x 96.5 cm
London, Wallace Collection

After Velázquez

Velázquez influenced many artists of his own generation, and his style and technique were evident in European painting up until the time of Pablo Picasso. Even before he had moved from Seville Velázquez's naturalistic painting style influenced painters such as Francisco Zurbarán (p. 58). Velázquez's *bodegones* struck out into new artistic territory and he was undoubtedly the foremost practitioner of this particularly Spanish genre;

a generation later his innovations were eagerly taken up by Bartolomé Estéban Murillo. Velázquez's reputation as one of the greatest 17th-century painters is, however, based primarily on the portraits of the royal family he painted as court artist to Philip IV. Among Velázquez's few known pupils perhaps the most talented was his son-in-law, Juan Bautista de Mazo; as a colleague and successor to Velázquez in the role of court painter his work is the best example of

Velázquez's immediate artistic legacy. The group portrait *Las Meninas* (pp. 84/85) was the direct inspiration for Mazo's picture of the artist's family, a work which at one time was ascribed to Velázquez. Mazo depicted members of his family in front of Velázquez's portrait of Philip IV (p. 86), while the artist is portrayed painting a portrait of the Infanta Margarita in the background. Velázquez developed a representational technique

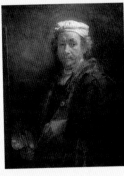

Above:
Rembrandt Harmensz van Rijn
Self-portrait Before the Easel, 1660
(detail)
Oil on canvas
110 x 86 cm
Paris, Musée du Louvre

which bears an astonishing resemblance to the late works of Rembrandt, as demonstrated by the latter's self-portrait of 1660. Fellow Spanish painter Francisco de Goya (1746–1828) is still more clearly indebted to the tradition of Velázquez. Shortly after being appointed court painter in 1799 he painted a portrait of the family of Charles IV. Inspiration for the work came from *Las Meninas*, which he had previously reproduced in an etching.

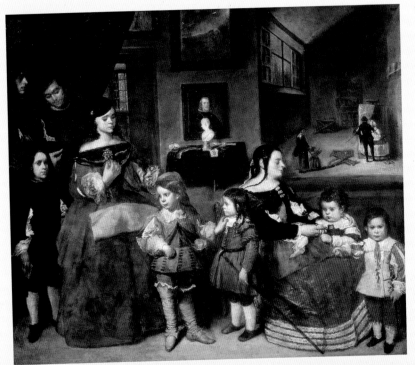

Juan Bautista Martínez del Mazo
The Artist's Family,
ca. 1660–1665
Oil on canvas
148 x 174.5 cm
Vienna, Kunsthistorisches Museum

Goya's technical ability to highlight details, such as those of his figures' clothes, while still achieving a unified composition, can be traced to Velázquez's influence. The same can be said of his capacity to bring out the inner life of his subjects – although in Goya's work this life is mercilessly exaggerated and caricature-like. Edouard Manet, one of the most outstanding innovators in the field of painting at the end of the 19th century, turned time and again to Velázquez's art and he often reworked motifs from the Spanish artist in his pictures. In his *Olympia*, Manet created a direct link to Velázquez's *Toilet of Venus* (p. 71) while developing the idea of the picture: the gaze of the nude subject which is directed out of the picture places the viewer in the role of an admirer who has sent the bouquet of flowers.

The juxtaposition of complete and incomplete sections within a picture as they appear in *The Coronation of the Virgin by the Trinity* (p. 70) also influenced the Impressionists. While in Madrid in 1865 Edouard Manet enthusiastically summed up the opinion of his peers by describing Velázquez as "the painter's painter."

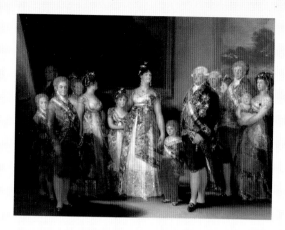

Above:
Francisco de Goya
The Family of Charles IV,
1800, Oil on canvas
280 x 336 cm
Madrid, Museo del Prado

Below:
Edouard Manet
Olympia, 1863
Oil on canvas
130 x 190 cm
Paris, Musée d'Orsay

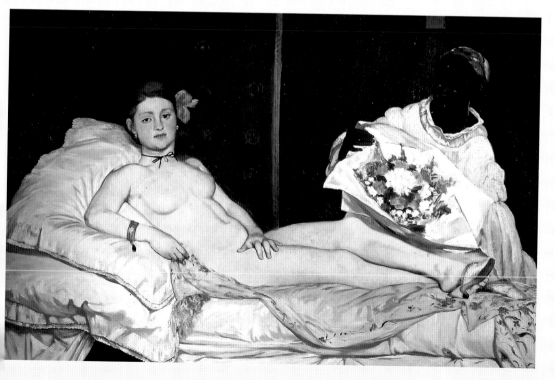

Glossary

Alcázar Spanish fortified palace.

Allegory (Gr. allegoria; from allegorein "illustrate differently") Simile; illustration of an abstract concept or content by means of a symbolic depiction generally as a personification (i.e. in the form of a person) or situation.

Antiquity (Lat. antiquus, old): The Greek and Roman Classical age began ca. 2000 B.C. and ended in the 5th century A.D. The art, literature and philosophy of the antique era influenced the Renaissance and later epochs.

Apotheosis (Gr. apotheoun "to deify," "to transfigure") Deification, transformation of a living being into a god.

Baroque (Portuguese barocco, "irregular") Stylistic movement in European art between ca. 1600 and 1750 that started in Rome and spread throughout Europe. The Baroque took various forms, depending on nationality and religious confession. Characterized by an extreme restlessness and experimentation with light and space, the term "barocco" was originally used by goldsmiths to denote an irregular pearl.

Bust (Fr. buste, "half-length portrait") generally a sculpture resting on a pedestal which is limited to a depiction of the upper torso, shoulders and head of a person.

Caravaggisti Group of painters heavily influenced by Michelangelo da Caravaggio (1571–1610). Key characteristic is the violent chiaroscuro contrasting between brilliantly illuminated figures and dark backgrounds.

Chiaroscuro (It. "light-dark") In painting the technique of modeling form in which the contrasts of light and dark define the composition and the effect of the picture. At the same time, localized color and clarity of outline are reduced. Vivid contrasts of light and shadow mean that the plasticity of objects and the modeling of materials become ways of dramatizing the events of the picture.

Composition (Lat. compositio, putting together) Formal construction developed according to certain principles e.g. the relationship of form and color, symmetry/asymmetry, movement, rhythm, etc.

Contour a shape's outline as a line or contrast.

Contrast Marked opposition between surfaces; painting differentiates between "light and dark contrast," "color contrast," "warm-cold contrast," "complementary contrast" or "simultaneous contrast."

Dionysus Also known as Bakchos (Lat. Bacchus), the god of wine and creative natural forces in Greek mythology; son of Jupiter and Semele; husband of Ariadne; brought up in a cave by nymphs, his torchlit rites were celebrated in the mountains to the accompaniment of music.

Drawing Design for a painting or sculpture, but may also be a work of art in its own right; a Drawing is considered the direct expression of an artistic idea in a graphic medium.

Genre painting (Fr. "kind, sort") Painting showing typical scenes and events from daily life, or focusing on a particular profession or social class.

Glaze (From medieval Lat. lazur(i)um, "bluestone" Arab. lazaward "lapis lazuli") Painting which applies thin, transparent layers of paint over a different color to alter its qualities.

Golden Fleece The Order of the Golden Fleece was an august chivalric order founded by Duke Philip the Good of Burgundy in 1429 in honor of the Apostle Andrew; its duties were to protect the Christian faith and defend the Church.

Guild of St Luke The guild was of medieval origin and developed out of the groups of tradesmen who banded together for economic reasons; this particular guild was composed of artists whose patron was St Luke. According to legend, St Luke is said to have painted a portrait of the Virgin.

History painting Type of painting depicting historical, legendary, Biblical or mythological incidents. Considered by art theorists of the 17th and 18th centuries to be the highest form of painting as it required artists to have first mastered all the subsidiary forms, i.e. portrait, landscape, still-life, and genre painting.

Iconography (Gr. eikon, "picture" and graphein "describe," "write") Theory of content, meaning and symbolism of pictorial depictions, especially in Christian art. Originally the study of portraits from antiquity.

Impressionism A form of expression in painting that gained in popularity at the end of the 19th century in France as a reaction against both the rigid doctrine of the French Academy and studio, history and genre painting with their prescriptive notions of content. The term was taken from a painting by Claude Monet entitled *Impression, rising sun* (Paris, Musée Marmoton; 1872)

and was initially used by critics as a derogatory term for a group of painters refused admission to the official Salon; these painters held their first independent exhibition in 1874 in the salon of the Parisian photographer Nadar. Impressionism regarded objects in nature as color phenomena.

Motif The main idea or theme of a work of art.

Mythology Sagas of the gods and heroes; mythology has been a popular subject for art since Classical times. Rediscovered in the Renaissance, mythology provided an inexhaustible source of themes for European painting.

Nude Depiction of the naked human body.

Oeuvre The entire output of an artist.

Oil painting Painting technique in which the ground pigments are bound with oil. Oil colors are elastic, dry slowly and can be worked into each other. Oil painting first came to prominence in the 15th century, since when it has become the dominant painting technique.

Ovid (43 B.C.–A.D. 18) Real name, Publius Ovidius Naso, a poet of Classical Rome. Author of the *Metamorphoses*, based on legends of transformation in Greek and Roman mythology; these tales can also be seen as describing an evolutionary process from a primeval world through to the order of the Augustan age.

Painters' guild Cooperative association of artists and artisans to protect their rights and interests. In almost all the great European cities of the 16th century, the guild controlled production and membership, mediated in disputes and provided for its members in the event of ill-health or other emergencies.

Palette An oval or kidney-shaped surface on which paints are mixed. Or the colors used by an artist or a color scale.

Pantheon (Lat. pantheum and Gr. pantheion "temple of all the gods") Ancient religious structure with a broad dome and portico with eight columns. Built between 115 and 125 A.D. in Rome under the emperor Hadrian (A.D. 76–138) as a temple to all the gods. In A.D. 609 it was rededicated as a Christian church. Since the Renaissance it has been used as a mausoleum for outstanding figures in the life of the city.

Patron One who commissions artworks, and protects and promotes the interests of the artist.

Pendant (Fr. "hanging") complement or related but independent opposite.

Perspective Method of representing three-dimensional space on a flat surface. There are several ways of achieving such a sense of depth. Among the most elementary are the use of overlapping (one object being placed behind another), and scale (near objects depicted larger than distant ones). In aerial perspective distant scenes are painted in lighter tones and less intense colors, and with less clarity.
In Western art since the Renaissance, the most important form of perspective has been linear perspective, in which the real or suggested lines of objects converge on a vanishing point (or points) on the horizon. This method was developed into a formal system in Italy during the early years of the 15th century, though an empirical sense of linear perspective had developed in Italy and northern Europe during the Middle Ages.

Physiognomy (Gr. physis "nature" and gnonai "to recognize") External appearance of a person, especially the face.

Portrait Painted depiction of a person. Types include: self-portraits, individual, dual and group portraits.

Profile Side view of a figure emphasized by the outline of the face and in which the forehead, nose and chin are especially strongly modeled to set them off from the background.

Proportion (Lat. proportio, "symmetry, harmony") Relationship of individual elements to each other and to the whole in a painting, sculpture or building.

Renaissance (It. rinascimento; Fr. "rebirth"): Important art historical era which began in Italy around 1420. The term "rinascita" (rebirth) was coined in 1550 by Giorgio Vasari (1511–1574), who intended it only to mean the superseding of Medieval art. By reassessing the models of classical art, Humanism promoted the concept of Nature, Man and the World oriented to a material existence. A characteristic feature of the Renaissance was the motif of the "uomo universale," an intellectually and physically gifted individual. The fine arts graduated from being a trade to become one of the liberal arts; the artist achieved a higher social status and a greater sense of self-confidence. The arts and sciences were closely and fruitfully related, as seen for example in the discovery of mathematically precise perspective or the advances in anatomical knowledge.

Sculpture One of the main branches of the fine arts, characterized by its use of three dimensions.

Self-portrait The artist's depiction of himself.

Still-life (Dutch still-leven; from still, "immobile" and leven, "model") Also referred to as *nature morte* or *natura morte* (Fr. "dead nature," and It. "lifeless creation"). Depiction of inanimate objects arranged artistically.

Subject Painting's theme or basic concept of a painting which defines its content.

Index